ART OFFICE

Second Edition

80+

BY CONSTANCE SMITH & SUE VIDERS

Art Network

ART OFFICE, 80+ BUSINESS FORMS, CHARTS, SAMPLE LETTERS, LEGAL DOCUMENTS & BUSINESS PLANS FOR FINE ARTISTS, SECOND EDITION

by Constance Smith and Sue Viders

Cover design by Laura Ottina Davis

Copyright © 2007 by ArtNetwork

Published by ArtNetwork, PO Box 1360, Nevada City, CA 95959
530·470·0862 800·383·0677 530·470·0256 Fax
www.artmarketing.com <info@artmarketing.com>

ArtNetwork was created in 1986 with the idea of teaching fine artists how to earn a living from their creations. In addition to publishing business books, ArtNetwork also has a myriad of mailing lists—which we use to market our products—available for rent to artists and art world professionals. See our web site for details.

Sue Viders can be contacted at 800.999.7013 or sueviders@comcast.net. Her web site is www.sueviders.com.

Publisher's Cataloging-in-Publication

Smith, Constance.
 Art office : 80+ business forms for the fine artist / by Constance Smith and Sue Viders --
2nd ed.
 p. cm.
 Includes index.
 ISBN: 0-940899-28-0
 13-digit ISBN: 978-0-940899-28-5

 1. Art--Marketing--Forms.
 2. Art--Economic aspects.
 3. Business--Forms I. Viders, Sue II. Title.

 N8353.V54 2007 706.8'8

 QB197-41365

INTRODUCTION

This book is designed to save fine artist times and energy in their business ventures. It includes basic forms that you will need throughout your career. Using these forms will save you lots of time organizing your office. It will also give your business a professional look, improve the impression you make on clients and, in turn, bring you increased sales and respectability. If you want, you can design your own forms based on our models.

All the 80+ forms and worksheets in this book are meant to be photocopied by you for your personal business use. Many forms apply to your in-house organizational needs. Some are to be used in doing business with customers. Comments about each form are found at the beginning of each chapter. If you don't understand how some of the forms can help you, you probably need to learn more about the business aspect of art. Review *Art Marketing 101* by Constance Smith (see page 11), another of ArtNetwork's business books for artists.

- The first three chapters of this book include general office forms to help you organize your office, do accurate bookkeeping and take care of the legal aspects of your career.

- The next two chapters provide you with inventory forms to help you keep track of your artwork, where you've sent samples, whom you need to follow up with, etc. They also have forms that will lead you to know what genre to target.

- The last three chapters present calendars to help you plan your marketing throughout the years, sample letters, pricing sheets and invoices.

We suggest you keep your photocopied forms in a three-ring binder. Divide your binder into chapters as we have done in this book. Consider color-coding your photocopies by section.

Running a fine-art business is much easier with a well-ordered file system. With this handy book of forms nearby, you can take the worry out of daily recordkeeping and routine tasks and put more time into keeping on top of your artwork.

Best of luck with your gowing career.

Constance Smith & Sue Viders

Table of Contents

CHAPTER 4 INVENTORY FORMS

CHAPTER 5 CUSTOMERS

CHAPTER 6 MARKETING PLANS

CHAPTER 7 SAMPLE LETTERS

CHAPTER 8 SALES DOCUMENTS

Daily Office Forms

- ### DAILY ORGANIZER
 This form is for daily planning. Keep these forms for your IRS records as well as for your personal reference.

- ### DAILY PLANNING SCHEDULE
 This is an alternative form to the above. Use this type of form daily. When you walk into your office or studio each morning, you will know precisely what your goals are for the day.

- ### FOR THE WEEK OF
 Each Friday try to fill out this form so you will have perspective on the following week.

- ### WEEKLY SCHEDULE
 This weekly overview will help you stay on track with important appointments.

- ### TWELVE-MONTH PLANNING CALENDAR
 Keep track of bigger projects on this yearly planner. Add projects to it as the year progresses.

- ### MEMO
 On the upper right side is space for your logo and address.

- ### FAX COVER SHEET
 This can be used as an introductory page for a multiple-page fax, or as your entire fax, with a hand-written message.

- ### MY FAVORITE WEB SITES
 It can be handy to have this listing on paper even with a bookmark keeper or your computer. If your e-mail software collapses, this might be your only backup!

- ### E-MAIL ADDRESS BACKUP
 Just in case your computer breaks down.

- ### E-MAIL ADDRESSES OF WORK SOLD
 A list to remind you to send them special e-mails

- ### E-MAIL ADDRESSES OF POTENTIAL CUSTOMERS
 Another list to remind you to start wooing these people

DAILY ORGANIZER

Date _____

TIME	PROJECT	APPOINTMENTS
7 AM		
8 AM		
9 AM		
10 AM		
11 AM		
Noon		
1 PM		
2 PM		
3 PM		
4 PM		
5 PM		
6 PM		
7 PM		
8 PM		
9 PM		

NOTES

TO DO

✓	ITEM

PHONE CALLS

✓	NAME	PHONE #	REASON

DAILY PLANNING SCHEDULE

9 AM	3 PM
10 AM	4 PM
11 AM	5 PM
Noon	6 PM
1 PM	7 PM
2 PM	8 PM

NOTES

FOR THE WEEK OF

THINGS TO DO

_____ ❏
_____ ❏
_____ ❏
_____ ❏
_____ ❏
_____ ❏
_____ ❏
_____ ❏

APPOINTMENTS

_____ ❏
_____ ❏
_____ ❏
_____ ❏
_____ ❏
_____ ❏

SPECIAL ATTENTION

_____ ❏
_____ ❏
_____ ❏
_____ ❏
_____ ❏
_____ ❏
_____ ❏

PHONE LOG

Name _____
Phone _____
Topic _____

Name _____
Phone _____
Topic _____

Name _____
Phone _____
Topic _____

Name _____
Phone _____
Topic _____

NOTES

WEEKLY SCHEDULE

Date _____

GOALS FOR THE WEEK	GOALS FROM LAST WEEK

	MONDAY		TUESDAY		WEDNESDAY
D O		**D O**		**D O**	
P H O N E		**P H O N E**		**P H O N E**	

	THURSDAY		FRIDAY		SATURDAY/SUNDAY
D O		**D O**		**D O**	
P H O N E		**P H O N E**		**P H O N E**	

TWELVE-MONTH PLANNING CALENDAR

JANUARY	FEBRUARY	MARCH

APRIL	MAY	JUNE

JULY	AUGUST	SEPTEMBER

OCTOBER	NOVEMBER	DECEMBER

MEMO

Date _____

To _____

From _____

Re _____

FAX COVER SHEET

Date _____ Number of pages (including cover) _____

TO	**FROM**

Name _____ Name _____

Company _____ Company _____

Telephone _____ Telephone _____

Fax # _____ Fax # _____

MY FAVORITE WEB SITES

URL	INFO

E-MAIL ADDRESS BACKUP

WHO	WHAT	ADDRESS

E-MAIL ADDRESSES OF WORK SOLD

WHEN	WHAT	WHO	ADDRESS

E-MAIL ADDRESSES OF POTENTIAL CUSTOMERS

WHO	WHY	ADDRESS

Bookkeeping Forms

- ### INCOME/EXPENSES
 This is a simplified form of a 12-column ledger.

- ### MONTHLY INCOME BY SOURCE
 This form helps you to analyze your annual income, providing you with valuable information for future planning. If, for example, you find that prints bring you the most money, you will probably continue to expand your business in that direction.

- ### FINANCIAL STATEMENT
 This is yet another tool to help you study your income trends, as well as where you might be overspending. This can be computed on a monthly or quarterly basis.

- ### ENTERTAINMENT/MEAL DOCUMENTATION
 This is a mandatory record required by the IRS if you plan to take deductions for entertaining.

- ### DAILY MILEAGE REPORT
 Yet another report required by the IRS. Keep a copy of this report in your car, filling in business miles and business purpose as they occur. At the end of the year you will arrive at your percentage of business usage for your vehicle by taking total miles travelled for the year and dividing that by business miles travelled for the year. You are allowed to take that percentage of your actual receipts for auto expense.

- ### TRAVEL DOCUMENTATION
 The IRS requires travel documentation when you take a trip for business purposes. This form will also help you budget future travel expenses. Staple receipts to the back for easy reference.

- ### PROJECTED BUDGET
 Estimating future income and expenses enables you to see what income activities have to be done to reach your aims. Revise this each quarter. Keep for reference.

- ### BALANCE SHEET
 Compile this annually to see where you stand financially.

- ### CHECK RECONCILIATION FORM
 Do this monthly to be sure you know your balance so you don't incur a bounced check charge.

INCOME/EXPENSES

Month of _____ , _____

INCOME

DATE	NAME/PAYOR	AMOUNT	ACCT #
	TOTALS		

EXPENSES

DATE	CHECK #	NAME/PAYEE	AMOUNT	ACCT #
		TOTALS		

MONTHLY INCOME BY SOURCE

	RENTALS	GALLERY	REPS	PATRONS	SHOWS	PRINTS	OTHER
January							
February							
March							
April							
May							
June							
July							
August							
September							
October							
November							
December							
TOTALS							

FINANCIAL STATEMENT

Month/quarter of _____ , ____

INCOME

Rentals ...

Gallery ...

Reps ...

Patrons ..

Shows ..

Prints ...

Other ...

TOTAL INCOME _____

EXPENSES

Advertising ..

Commissions ...

Insurance ..

Dues ..

Legal ..

Postage ..

Printing ..

Rent ...

Supplies ...

Taxes ...

Travel ...

Utilities ..

Other ...

TOTAL EXPENSES _____

NET PROFIT _____

ENTERTAINMENT/MEAL DOCUMENTATION

DATE	PLACE OF ENTERTAINMENT	BUSINESS PURPOSE	RELATIONSHIP OF PERSON TO TAXPAYER	AMOUNT SPENT

DAILY MILEAGE REPORT

DATE	ODOMETER		MILES	DESTINATION	PURPOSE
	START	END			

TRAVEL DOCUMENTATION

Trip to _____ Business purpose _____

Date: From _____ to _____ Number of days spent _____

DATE	PLACE	BKFST	LUNCH	DINNER	GUESTS	AMOUNT

STAPLE RECEIPTS TO BACK OF THIS FORM

PROJECTED BUDGET

MONTH OF	JAN	FEB	MARCH	APRIL	MAY	JUNE
INCOME						
Rentals						
Gallery						
Reps						
Patrons						
Shows						
Prints						
Other						
Total Income						
EXPENSES						
Advertising						
Commissions						
Insurance						
Dues						
Legal						
Postage						
Printing						
Rent						
Supplies						
Taxes						
Travel						
Utilities						
Other						
Total Expenses						
NET PROFIT						

BALANCE SHEET

ASSETS	
Cash	_____
Petty cash	_____
Accounts receiveable	_____
Inventory	_____
Prepaid expenses	_____
Longterm investments	_____
Equipment	_____
Furniture	_____
Auto/vehicle	_____
Misc assets	_____
Total assets	$ _____ **(A)**

LIABILITIES	
Accounts payable	_____
Loans payable	_____
Fed taxes payable	_____
State taxes payable	_____
Self-employment taxes payable	_____
Sales tax payable	_____
Total liabilities	$ _____ **(B)**
Total equity/net worth	$ _____ **(C)**

ASSETS = LIABILITIES + EQUITY (A = B + C)

CHECK RECONCILIATION FORM

OUTSTANDING CHECKS

Check number Amount

_____|_____

_____|_____

_____|_____

_____|_____

_____|_____

_____|_____

_____|_____

_____|_____

_____|_____

_____|_____

Total outstanding checks (A) | $ _____

Statement balance (B) | $ _____

Deposits not credited on this statement | $ _____

_____|_____

_____|_____

_____|_____

_____|_____

Total deposits (C | $ _____

Total B + C (D | $ _____

 Subtract A from D (_____)

Total should agree with your register balance $ _____

Legal Agreements

The following sample contracts are just that—samples of what you want to have your legal agreement contain. They are pro-artist. It is impossible to cover every contingency that might occur, so you will need to adapt these sample agreements to your specific situation. State laws vary and change. If you are given a contract by a gallery owner, remember that you can and should change clauses you don't agree with. It's best to consult a lawyer whenever you enter into a contractual relationship. Always make two copies of any contract—one for you and one for the second party—dated and signed in ink by all parties.

- ## CHECKLIST FOR CONTRACTS
This is a checklist noting what contracts need to contain—it is not a contract. Only in cases where large amounts of money and complexities of arrangements are involved would all these points be used.

- ## SALES AGREEMENT
This serves as a receipt and record of the transfer of funds for the ownership of an artwork. It also states the artist's retention of reproduction rights. Use this agreement for professional sales, for example, to a corporation. For private collectors, use the one on page 100.

- ## EXHIBITION AGREEMENT
This form documents the transfer of artwork without the transfer of ownership for the purpose of exhibition. Outlining such details makes sure everyone involved understands all aspects.

- ## ARTIST-GALLERY AGREEMENT
Galleries often want to use their own legal agreements. Read them carefully, comparing them to this one. You might find some areas "twisted" to benefit the gallery!

- ## CONSIGNMENT SCHEDULE
According to the California Penal Code (section 536, subparagraph a), every merchant who sells consigned work must, upon written demand, provide the consignor (Artist) with the names and addresses of the purchaser, the quantity of works sold, and the prices obtained.

- ## ARTIST-GALLERY CONSIGNMENT AGREEMENT
This form is a version of the combined Artist-Gallery Agreement and Consignment Schedule. This document indicates transfer for sale, showing that ownership is still in the hands of the artist. Should the gallery go bankrupt, for instance, it shows that they are not the owners of these artworks and creditors cannot claim your artwork.

- ## WORK AGREEMENT
An important agreement if you want to keep rights to your creations when you are hired

- **MODEL RELEASE**

 Use this release any time you are drawing from a live figure or photography. You never know when you will use that drawing to help you in a final artwork displayed in public. You could get sued by the model if you don't have this signature.

- **PROPERTY RELEASE**

 This is a similar form to a model release, but it applies to real estate.

- **COMMISSION AGREEMENT**

 Delete from or add to this contract details necessary for your particular project. Be sure to take several digital shots of the piece before you relinquish it. You may need this digital version for your promotional material or to accompany an article on your work.

- **RENTAL-LEASE AGREEMENT**

 This agreement is important, whether it be signed by a large corporation or a private collector. Change the terms as you deem best. Keep it simple enough for a novice to comprehend.

- **ARTIST-AGENT AGREEMENT**

 If you're fortunate enough to hook up with a rep, don't neglect to write a formal agreement. Attach a Consignment Schedule confirming that you own the artwork until it is paid for in full.

- **FORM VA**

 Form VA is sent directly to the Washington DC copyright office. Instructions are those of the government (reprinted with their permission). There is also a Short Form VA.

CHECKLIST FOR CONTRACTS

❑ Parties involved

Gallery: Continuity of personnel, location. Assignability.

Artist: Extension to spouse, children. Estate.

❑ Duration. Fixed term, contingent on sales/productivity. Options to extend term. Different treatment of sales at beginning and end of term.

❑ Scope. Media covered. Past and future work. Gallery's right to visit the studio. Commissions. Exclusivity. Territory, studio sales, barters or exchanges, charitable gifts.

❑ Shipping. Who pays to/from gallery. Carriers. Crating.

❑ Storage. Location, access by artist.

❑ Insurance. What's protected in-transit/on-location.

❑ Framing. Who pays for framing; treatment of expense on works sold.

❑ Photographs. Who pays, amount required (B&W and color), ownership of negatives/transparencies, control of films.

❑ Artistic control. Permission for book/magazine reproduction. Inclusion in gallery group exhibits. Inclusion in other group exhibits. Artist's veto over purchasers.

❑ Gallery exhibitions. Dates. Choice of works to be shown. Control over installation. Advertising. Catalog. Opening. Announcements/mailings.

❑ Reproduction rights. Control prior to sale of work. Retention on transfer or sale of work. Copyrights.

❑ Damage/deterioration. Choice of restorer. Expense/compensation to artist. Treatment for partial/total loss.

❑ Protection of the market. Right of gallery to sell at auction. Protection of works at auction.

❑ Selling prices. Initial scale. Periodic review. Permission if discounts are offered. Negotiation of commissioned works. Right to rent vs. sell.

❑ Billing and terms of sale. Extended payment, credit risk, allocation of monies as received, division of interest charges, qualified installment sale for tax purposes. Exchanges/trading up. Returns.

❑ Compensation of the gallery. Right to purchase for its own account.

❑ Income from other sales. Rentals. Lectures. Prizes/awards. Reproduction rights.

❑ Accounting/payment. Periodicity. Right to inspect financial records. Currency to be used.

❑ Advances/guarantees. Time of payment. Amounts and intervals. Application to sales.

❑ Miscellaneous. Confidentiality of artist's personal mailing list. Resale agreements with purchasers. Right of gallery to use artist's name and image for promotional purposes.

❑ General provisions. Representations and warranties. Applicable law. Arbitration.

SALES AGREEMENT

Agreement made this _____ day of _____, ____, between _____ (hereinafter called "Artist"), residing at _____, and _____ (hereinafter called "Purchaser"), residing at _____.

1. DESCRIPTION OF WORK.

Title _____ Medium _____

Size _____ Year created _____

2. PAYMENT. The Artist shall sell the Work to the Purchaser, subject to the conditions herein, for a price of $ _____ (dollars). The Purchaser shall also pay all applicable taxes.

3. INSURANCE, SHIPPING, AND INSTALLATION. The Artist agrees to keep the Work fully insured against fire and theft until delivery to the Purchaser. In the event of a loss caused by fire or theft, the Artist shall use the insurance proceeds to recommence the making of the Work. The Work shall be shipped F.O.B. Artist's studio at the expense of the Purchaser to the address above.

4. ARTIST'S RIGHTS.

 a. Copyright and Right to Credit. The Artist reserves all rights of reproduction and all copyright on the Work, the preliminary design, and any incidental works made in the creation of the Work. The Work may not be photographed, sketched, painted, or reproduced in any manner whatsoever without the express written consent of the Artist.

 b. Right to Possession. The Artist and the Purchaser agree that the Artist shall have the right to show the Work for up to sixty (60) days once every five (5) years at no expense to the Purchaser, upon written notice not later than ninety (90) days before opening of show and upon satisfactory proof of insurance. All costs incurred from for delivery and return will be the responsibility of the Artist.

 c. Non-destruction/Alteration. The Purchaser agrees that he/she will not intentionally destroy, alter, damage, modify, or otherwise change the Work in any way whatsoever.

 d. Repairs/Maintenance. The Purchaser shall be responsible for the proper cleaning, maintenance, and protection of the Work in his/her possession, if on loan or otherwise exhibited, notwithstanding anything contrary herein. All repairs and restorations made during the Artist's lifetime shall have the Artist's written permission. The Artist shall be consulted as to his/her recommendations with regard to all such repairs and restorations, and will be given the opportunity to accomplish such repairs as he/she deems necessary.

 e. Resale of Work. If the Purchaser sells or transfers the Work, the Purchaser shall pay to the Artist a sum equal to fifteen percent (15%) of the appreciated value of the work and shall obtain from the new purchaser or transferee a binding undertaking to observe all of the provisions of this Agreement in the interest of the Artist. The Artist shall be given the new owner's name and address. For the purposes of this agreement, appreciated value shall mean the sales price of the artwork less the original purchase price as stated in this agreement.

5. NOTICES AND CHANGES OF ADDRESS. All notices shall be sent to the addresses noted above. Each party shall give written notification within sixty (60) days of any changes of address.

6. NO ASSIGNMENT OR TRANSFER. Neither party hereto shall have the right to assign or transfer this agreement without the prior written consent of the other party.

7. HEIRS AND ASSIGNS. This agreement shall be binding upon the parties hereto, their heirs, successors, assigns, and personal representatives, and references to the Artist and the Purchaser shall include their heirs, successors, assigns, and personal representatives.

8. SEVERABILITY. If any part of this Agreement is held to be illegal, void, or unenforceable for any reason, such holding shall not affect the validity and enforceability of any other part.

9. GOVERNING LAWS. The validity of this agreement and of any of its terms, as well as the rights and duties of the parties under this agreement, shall be governed by the laws of the State of _____.

IN WITNESS WHEREOF the parties have hereunto set their hands this day of _____, _____.

ARTIST _____ DATE _____

PURCHASER _____ DATE _____

EXHIBITION AGREEMENT

This is an agreement entered into on _____, between _____ ("Artist") and _____ (name of space and/or name of owner) or exhibition space ("Space"). The purpose of this agreement is to set out the understandings which shall govern an exhibit by Artist of certain works of art in such Space. The exhibit shall be on public display from _____ through _____. The space shall be open to the public from ____ AM to ____PM, _____ (M-F, Sat only, etc.). The opening shall be held on _____ at _____AM/PM.

Artist shall have access to the Space for preparation, storage of works and installation ____ days before the opening and shall have ___ days after the exhibit closes within which to remove art works from the Space. Decision as to disposition of works not removed by that time will be made solely by Space owner.

Artistic judgment with respect to installation of the work in the Space shall rest solely with _____. Space shall provide installation fixtures, including mountings, tape, pins, nails, etc., as required.

Upon request of Space, by date _____, Artist shall advise the Space of the approximate number and type of works to be installed and shall provide to the Space a schedule of titles, descriptions, prices and insurance values for each work. Space shall insure the works for the values assigned by the Artist from the period when the Artist first delivers the works to Space until removal of works by the Artist or until the date all works must be removed from Space, whichever is later. Space is responsible for security of works in storage areas and also during all hours when the exhibit is not on public display. Space represents that it is in sound repair and Space shall be responsible for damage to the works occasioned by structural defects, water damage or the like. Space shall exercise reasonable care in dealing with the works. No work shall be removed during the period of the exhibit, and buyers of any work shall be informed of this policy.

Commission on sale of works on exhibit shall be ____%.

All publicity shall state the name and address of the Space. Artist shall be responsible for publicity and promotion, including posters, any catalog, announcements and the mailing thereof, news coverage by newspaper, magazine, radio, or television, and paid advertising, except as follows: _____.

Artist shall arrange and be financially responsible for refreshments at the opening.

The Space shall maintain the Space in a good state of repair, clean and orderly.

All disputes arising out of this Agreement shall be submitted to final and binding arbitration. The arbitrator shall be selected in accordance with the rules of Arbitration and Mediation Services. If such service is not available, the dispute shall be submitted to arbitration in accordance with the laws of _____. The arbitrator's decision shall be final, and judgment may be entered upon it by any court having jurisdiction thereof.

Both parties agree that this represents the entire understanding between them, and that it shall be a binding contract upon signature by an authorized representative of the Space and the Artist.

ARTIST _____ DATE _____

SPACE OWNER/AUTHORIZED REPRESENTATIVE _____ DATE _____

ARTIST-GALLERY AGREEMENT

This is an Agreement between ("Artist") _____, residing at _____, and ("Gallery") _____ , at _____.

The terms of this Agreement are as follows:

1. **Limited, Exclusive Agency.** Artist hereby appoints Gallery his exclusive/non-exclusive agent for the sale and exhibition of his works of art in the following geographical area:_____. The Gallery shall have the right of first selection of works produced by Artist for inclusion in the show(s) which it will present. Any works not selected by the Gallery may be sold by the Artist.

2. **Creation, Title and Receipt.** Artist hereby warrants that he created and possessed unencumbered title to, and Gallery acknowledges receipt of, the works of art on the attached Consignment Schedule ("Schedule").

3. **Sales.** Sales shall be made at a price not less than the price ("Retail $") on Schedule, which doesn't include sales tax or delivery costs. The Gallery will supply the Artist with its signed resale certificate and its resale number for Artist's records. Gallery shall receive _____% commission on the sales price on sales made by Gallery; _____ % of the sales price on sales made directly by the Artist; _____ % of the rental fees on rentals arranged by the Gallery; _____ % of the amount received for prizes and awards granted to the Artist when such prizes and awards are obtained for the Artist by the Gallery; _____ % of lecture fees for lectures arranged for the Artist by the Gallery. The Gallery may give a trade discount, which shall not exceed _____% of sales price without the Artist's written consent on sales to museums, gall___, decorators and architects. In the case of such discount sales, the amount of the discount shall be deducted from the Gallery's sa___ ommission. The Gallery shall use its best efforts to promote the sale of the Artist's consigned works, to support a market for the A___ t's work, and to provide continuous sales representation in the following manner: _____ _____.

4. **Payment on Gallery's Sales.** On outright sales: Gallery shall pay Artist the balance of sales price after its commission within thirty (30) days of purchaser's payment to Gallery. If purchaser pays in installments, all monies received by Gallery from purchaser shall be distributed pro rata to Artist and Gallery in accordance with their respective percentage shares of the total sale price, and Artist's share shall be paid within thirty (30) days of Gallery's receipt of any installment payment until Artist's share is paid in full. It is expressly agreed that any default of a purchaser from Gallery shall be borne solely by Gallery and Gallery shall, notwithstanding such default, pay Artist his percentage share of sales price within one hundred eighty (180) days of any such sale on installment terms.

5. **Payment on Artist's Sales.** The Gallery shall receive _____ % of any sales made by the Artist personally, without the assistance of the Gallery, provided, however, that no commission shall be paid on any sales referred to in this paragraph, unless the Gallery makes sales in the contract year of at least $ _____ for the Artist. Artist shall pay Gallery its commission within thirty (30) days of the purchaser's payment to Artist. If purchaser pays in installments, Artist shall pay Gallery its percentage share of each payment by purchaser to Artist within thirty (30) days of Artist's receipt of any installment payments.

6. **Commissions.** Gallery shall be entitled to receive _____ % of the price of any commissions given to Artist to create works of art when such commissions are obtained for him by Gallery, and _____ % of any such commissions Artist procures during the term of this Agreement.

7. **Exhibitions.** During the term of this agreement, Gallery shall hold at least __ solo exhibition(s) every _____ months for Artist and shall use its best efforts to arrange other solo exhibition(s) for Artist and for the inclusion of Artist's work in group exhibitions in other galleries or museums, provided, however, that Artist's work may not be included in any group exhibition without his prior written consent. Failure to do so shall entitle Artist to terminate this Agreement upon thirty (30) days' written notice to Gallery. Although the Gallery may arrange for representation of the Artist by another agency with the Artist's written consent, the Gallery shall pay such agency by splitting its own commission. When the Artist has a one-man show at the Gallery, all related costs will be borne by the Gallery for such exhibition; including, but not limited to, advertising, printing, reception, framing, packing and freight. Should the Gallery lend out for approval to a client a piece of Artwork by said Artist, the Gallery will be responsible for Artist's commission if work is stolen, lost or damaged, just as in a sale. Should the piece not be returned within seven days, it will be considered sold and Artist will expect his commission in due time as provided in this contract. Should the Artist give the Gallery his mailing list to use for any exhibit, the Gallery shall respect confidentiality of same and only use it for the Artist's personal show. After the exhibition, frames, photographs, negatives and any other tangible property created in the course of the exhibition shall be the property of the Artist. The _____ shall bear the cost of shipping the works to the Gallery. The _____ shall bear the cost of framing. The Gallery shall bear all other costs incident upon the show. The Artist shall be free to exhibit and sell any work not consigned to the Gallery under this Agreement.

8. **Rented Artwork.** A Rental Agreement must be signed by interested party and Artist.

9. **Statements of Account.** Gallery shall give Artist a Statement of Account within fifteen (15) days after the end of each calendar quarter.

The Statement shall detail Artist's works sold/rented/leased during the calendar quarter (to include at least price, date, name and address of purchaser, payments made to Artist, payments owed Artist on installment purchases, and location of any unsold work not located at Gallery.

10. **Reproduction Rights.** Artist hereby reserves the right to copy, photograph or reproduce each work of art consigned to Gallery. Gallery agrees that it will not permit any of the works of art to be copied, photographed or reproduced except for the purpose of appearing in a catalog or advertisement without the prior written consent of Artist and will state, "The right to copy, photograph or reproduce the work(s) of art identified herein is reserved by the Artist." Notwithstanding the foregoing, reproduction rights may be specifically sold by Gallery with the Artist's prior written consent. Gallery shall not receive any commissions on royalties or licensing of reproduction rights unless sold or arranged by Gallery, in which case Gallery's commission shall be _____%. Artist is free to procure publisher at own time and expense. Gallery will receive no commissions on these procurements.

11. **Insurance.** Gallery will provide all-risk insurance on Artist's works of art listed on the Schedule of up to ____% of retail price.

12. **Termination of Agreement.** This Agreement shall terminate on _____. Upon termination, Gallery shall return within thirty (30) days all Artist's works of art which are held on consignment.

13. **Return of Works.** All costs of return (including packing, transportation and insurance) shall be paid as follows: ___% by the Artist, ____% by the Gallery. The Gallery may return any consigned work on thirty (30) days' written notice. The Artist may withdraw his consigned work on thirty (30) days' written notice. If the Artist fails to accept return of the works within ___ days after written request by the Gallery, the Artist shall pay reasonable storage costs. The Gallery agrees to return consigned works in the same good condition as received.

14. **Loss or Damage.** The Gallery shall not intentionally commit or authorize any physical defacement, mutilation, alteration, or destruction of any of the consigned works. The Gallery shall be responsible for the proper cleaning, maintenance, and protection of consigned work, and shall also be responsible for the loss or damage of consigned work, whether the work be on the Gallery's premises, on loan, on approval, on rental/lease or otherwise removed from its premises.

15. **Maintenance.** If restoration is undertaken for any consigned work, all repairs and restoration shall have the Artist's written permission. The Artist shall be consulted as to his recommendations with regard to all such repairs and restoration, and will be given first opportunity to accomplish said repairs and restoration for a reasonable fee.

16. **Miscellaneous.** This Agreement may not be assigned by Gallery without Artist's prior written consent. This Agreement constitutes the entire understanding between the parties. Its terms cannot be modified except by an instrument in writing signed by the parties involved. A waiver of any breach of any of the provisions of this Agreement shall not be construed as a continuing waiver of other breaches of the same or other provisions hereof.

17. **Arbitration.** All disputes arising out of this Agreement shall be submitted to final and binding arbitration. The arbitrator shall be selected in accordance with the rules of Arbitration and Mediation Services. If such service is not available, the dispute shall be submitted to arbitration in accordance with the laws of _____. The arbitrator's decision shall be final, and judgment may be entered upon it by any court having jurisdiction thereof.

18. **Severability.** If any part of this Agreement is held to be illegal, void or unenforceable for any reason, such holding shall not affect the validity and enforceability of any other part.

19. **Moral Right.** The Gallery will not permit any use of the Artist's name or misuse of the consigned works which would reflect discredit on his reputation as an artist or which would violate the spirit of the work.

20. **Security.** The consigned works shall be held in trust for the benefit of the Artist, and shall not be subject to claim by a creditor of the Gallery. In the event of any default by the Gallery, the Artist shall have all the rights of a secured party under the Uniform Commercial Code.

21. **Governing Law.** This agreement shall be governed by the laws of the State of _____.

ARTIST _____ DATE _____

GALLERY OWNER/AGENT _____ DATE _____

CONSIGNMENT SCHEDULE

Artist _____

Address _____

City/State/Zip _____

Telephone _____

Consignee _____

Address _____

City/State/Zip _____

Telephone _____

TITLE/DESCRIPTION	MEDIUM	SIZE	FRAMED	RETAIL $	COMMISSION	NET $

ARTIST _____Date _____

CONSIGNEE _____Date _____

ARTIST-GALLERY CONSIGNMENT AGREEMENT

TITLE/DESCRIPTION	MEDIUM	SIZE	FRAMED	RETAIL $	COMM	NET $

1. The Gallery confirms receipt of the Artist's consigned artworks, in perfect condition unless otherwise noted.

2. This agreement applies only to works consigned under this agreement and noted above.

3. The Artist reserves the copyright and all reproduction rights to these works. The Gallery **will not** permit any of the artworks to be copied, photographed, reproduced or transferred to a CD-ROM for use on a computer network without written permission of Artist. Gallery will print on each bill of sale, "The right to copy, photograph or reproduce the artwork(s) identified here is reserved by the Artist, _____."

4. The retail amount (less the Gallery commission) and the name and address of the purchaser will be remitted to the Artist within thirty (30) days after the sale. The title to these works remains with the Artist until the works are sold and the Artist is paid in full, at which time the title passes directly to the purchaser.

5. The Gallery will assume full responsibility for any consigned work lost, stolen or damaged while in its possession. Consigned works **may not** be removed from Gallery premises for purposes of rental, installment sales or approval with a potential purchaser without Artist's permission. The specified retail prices **may not** be changed without the Artist's permission.

6. The consigned works will be held in trust for Artist's benefit and will not be subject to claim by a creditor of the Gallery. This agreement will terminate automatically upon Artist's death, or if Gallery becomes bankrupt or insolvent. Either party may terminate this agreement by giving thirty (30) days written notice, with all accounts settled.

Artist Name _____ Gallery Name _____

Address _____ Address _____

City _____ State ___ Zip _____ City _____ State ___ Zip _____

Phone _____ Phone _____

SIGNATURE OF ARTIST _____

SIGNATURE OF GALLERY DIRECTOR _____

WORK AGREEMENT

Agreement made this _____ day of _____ 20___, between _____ _____ (hereinafter "Company") and _____ (hereinafter "Artist") for the preparation of _____ artwork(s) for the _____ (hereinafter "Project").

Witnesseth:

NOW, WHEREFORE, in consideration of the mutual covenants and promises set forth herein, the parties agree as follows:

1. Artist shall submit the artworks in finished form no later than _____.

2. Company will pay Artist the sum of $_____ for each artwork, to be paid one quarter upon signing of this agreement, one quarter upon delivery of preliminary studies, and one half upon delivery of the finished artwork.

3. Any and all artwork created pursuant to this agreement shall remain in the possession of the Artist, including copyright to the work, for any and all purposes throughout the world, except for the specific purpose contained herein.

4. Artist represents and warrants that he/she is the creator of the artwork specified herein, that it does not infringe on any rights of copyright or personal rights and rights of privacy of any person or entity and that any necessary permissions have been obtained.

5. Artist agrees that he/she is working as an independent, free-lance contractor and will be responsible for payment of all expenses incurred in his/her preparation of said artwork.

IN WITNESS WHEREOF, the parties hereto have duly executed the agreement the day and year first above written.

ARTIST _____ DATE _____

COMPANY _____ DATE _____

PROPERTY RELEASE

I hereby grant the irrevocable right, as owner of property noted below, to use of the likeness in any and all media and in any and all manners including composite or segmented representation for the preparation of works of art or any other lawful purpose.

I hereby waive my rights to approval/rejection of the completed works which may incorporate said property, and hold harmless the Artist and the Artist's representatives against any and all liability arising therefrom.

I am an adult living in the State of _____. I have read this property release and understand its contents.

DATE _____

OWNER OF PROPERTY _____

ADDRESS OF PROPERTY _____

DESCRIPTION OF PROPERTY _____

SIGNATURE OF OWNER _____

NON-DISCLOSURE AGREEMENT

I (hereinafter referred to as the first party)_____,

Address _____, City_____, State _____,

Zip _____ Telephone _____

Name (hereinafter known as second party) _____,

Address _____, City_____, State _____,

Zip _____ Telephone _____.

Whereas, the first part is desirous of revealing information to the second party for assistance in developing said information and/or evaluation purposes to study the feasibility of entering into an agreement with the second party for commercially exploiting a product in accord with the information;

Therefore, it is agreed by the second party that any information received from the first party, orally or in writing, will be maintained in confidence and will not be published or disclosed to third persons without the express written consent of the first party.

SECOND PARTY _____ DATE _____

MODEL RELEASE

On _____, I, _____, posed as a model for artwork (to be) created by _____. In consideration of the payment of the sum of $ _____ at the conclusion of this modeling assignment, I hereby grant the irrevocable right to the use of my likeness in any and all media and in any and all manners including composite or segmented representation for the preparation of works of art or any other lawful purpose. I hereby waive my rights to approval/rejection of the completed works which may incorporate my image, and hold harmless the Artist and the Artist's representatives against any and all liability arising therefrom.

I am an adult living in the State of _____. I have read this model release and understand its contents.

DATE _____

MODEL _____

ADDRESS _____

IF MODEL IS MINOR

As Parent/Guardian of the above-named Model who is underage, I hereby consent to all the terms stated above and accept on behalf of the Model the consideration set forth above.

DATE _____

PARENT/GUARDIAN _____

COMMISSION AGREEMENT

This Agreement is made the _____ day of _____, between _____ ("Artist") residing at _____ _____ and _____ ("Purchaser") residing at _____ _____. Artist agrees to execute the "Commissioned Work" and Purchaser agrees to pay for and accept delivery of the Commissioned Work subject to the terms and conditions of this Agreement. A description of the Commissioned Work (size, material, scope): _____ _____.

PRICE. In consideration of Artist's services (including labor, equipment and materials), Purchaser shall pay Artist the total purchase price of $_____ in three equal installments. The first installment shall be paid upon signing this Agreement and is nonrefundable; the second upon 50% completion of the work. The final payment shall be paid on or before the date of delivery of the Commissioned Work, of which Artist will give five (5) days notice. The Purchaser shall pay the applicable sales tax with the final payment and sign a purchase and sales agreement.

DELIVERY, INSURANCE, INSTALLATION. Artist shall make a good faith effort to execute Commissioned Work to the satisfaction of the Purchaser prior to delivery. In the event, however, that the Purchaser shall refuse to accept delivery of the Commissioned Work as executed (whether such refusal is reasonable or not), the Purchaser shall nonetheless be liable for payment of the second installment as if the Commissioned Work had actually been delivered. Ownership of the Commissioned Work and all rights therein shall remain with the Artist if the Purchaser refuses to accept delivery under such circumstances. Artist agrees to keep the Commissioned Work fully insured against fire and theft until delivery to the Purchaser and bear any other risk of loss. _____ pays for delivery to site; _____ pays for return delivery to Artist.

DATE OF DELIVERY. The Artist agrees to deliver Commissioned Work on or before _____. If Artist fails for any reason to make delivery within such period, Artist shall be entitled to extend the delivery date for a reasonable period thereafter, not exceeding a total of 60 days. If Artist fails to make delivery on or before such extended delivery date, Purchaser shall be entitled to refuse to accept delivery of the Commissioned Work without liability to pay the second or third installment. Purchaser shall not be entitled to recover payment of the first installment. Ownership of the Commissioned Work and all rights therein shall remain with the Artist if the Purchaser refuses to accept delivery under such circumstances.

COPYRIGHT, OWNERSHIP. Commissioned Work is copyrighted in Artist's name. Artist also retains ownership of all rights to any preliminary drawings or sketches which may be made in connection with the execution of the Commissioned Work. Copies of finished art cannot be reproduced without Artist's written consent.

RESALE RIGHTS. If the Purchaser sells, barters, exchanges, trades, donates, or otherwise transfers Commissioned Work to another person, the Purchaser shall pay the Artist a sum equal to fifteen percent (15%) of the appreciated value. In the case of transfer, the appreciated value means the difference between the fair market value of the Commissioned Work at the time of transfer and the total purchase price under this Agreement. No payment shall be required under this Article if the Purchaser donates Commissioned Work to a museum or other nonprofit institution, unless the Purchaser claims a tax deduction in respect of such donation, in which case the Purchaser shall pay the Artist a sum equal to 15% of the difference between such deduction and the total purchase price of this Agreement.

NON-DESTRUCTION. The Purchaser shall not intentionally destroy, change, damage, modify or otherwise alter Commissioned Work. All repairs and restorations made during the lifetime of the Artist must have his approval. To the extent that it is practical, the Artist shall be given the opportunity to accomplish said repairs and restorations for a reasonable fee.

BORROWING. The Artist shall have the right, upon giving reasonable notice to the Purchaser, to borrow Commissioned Work for a period not exceeding sixty (60) days during any one (1)-year period for the purpose of public exhibition. If the Purchaser intends to exhibit the Commissioned Work publicly, he/she shall notify the Artist not less than thirty (30) days prior to the exhibition. Such notice shall include the name and address of the exhibiting institution, the date of the exhibition, and the name of the curator or other person responsible for the exhibition. Should there be a rental fee, the rental fee for exhibition of Commissioned Work shall be divided equally between Artist and Purchaser. Purchaser gives to Artist permission to use Purchaser's name, picture/portrait and photograph in all forms and media and in all manners, including but not limited to exhibition, display, advertising, trade and editorial uses, without violating Purchaser's rights of privacy.

MISCELLANEOUS. Each party shall give written notification to other party of change of address prior to the date of said change. All disputes arising out of this agreement shall be submitted to final and binding arbitration. The arbitrator shall be selected in accordance with the rules of _____. The arbitrator's award shall be final and judgment may be entered upon it by any court having jurisdiction thereof.

ARTIST _____ DATE _____

PURCHASER _____ DATE _____

RENTAL-LEASE AGREEMENT

Renter/Leasor _____

Address _____

City/State/Zip _____

Telephone _____

Artist/Agent _____

Address _____

City/State/Zip _____

Telephone _____

TERMS AND CONDITIONS

1. Rental/lease period is three (3) months. Artwork may be re-rented successively for one year, at which time it must be purchased or returned. _____ percent (___%) of rental fees can be applied to purchase price. Renter agrees to handle carefully and return on due date or pay overdue charge of $_____ per day. Rental and renewal fees are payable in advance.

2. Renter/leasor shall be responsible during rental term for loss or damage to said property from whatever cause, including fire and theft. Artwork may not be painted or altered. Artwork may not be transferred to another person's care.

3. At the expiration, termination or default of this Rental/Lease Agreement, renter/leasor agrees to return said property to artist in original condition.

Title _____ Medium _____ Size _____

List any abnormal condition of work here: _____

Start date _____ End date _____ Rental Fee _____ Sales Price _____

This agreement is subject to the terms and conditions above.

ARTIST _____ DATE _____

RENTER/LEASOR _____ DATE _____

ARTIST-AGENT AGREEMENT

This Agreement is made this day of _____, _____, between _____ ("Artist"), residing at _____ and _____ _____ ("Agent"), residing at _____.

The parties agree as follows:

Artist appoints Agent as Artist's exclusive/non-exclusive agent for the purpose of representation and sale of works of art within the following geographical area:_____.

1. Fee

Artist shall secure the services of Agent by advance payment of a retainer fee of $ _____ per month to initiate sales for Artist. Retainer fee covers a minimum of _____ hours of work per month.

2. Duties of Agent

Agent agrees to use reasonable efforts in the performance of the following duties: promote and publicize Artist's name and talents; carry on business correspondence on Artist's behalf relating to Artist's professional career; cooperate with duly constituted and authorized representatives of Artist in the performance of such duties. Agent shall fully comply with all applicable laws, rules and regulations of governmental authorities and secure such licenses as may be required for the rendition of services hereunder.

3. Rights of Agent

Agent may/may not render similar services to other artists. Agent may publicize the fact that Agent is the agent for Artist. Agent shall have the right to use or to permit others to use Artist's name and likeness in advertising or publicity relating to Artist's services, consignments, commissions, rentals, or public showing but without cost or expense to Artist unless Artist shall otherwise specifically agree in writing.

4. Sales Commission

Artist's work shall be held on consignment with Agent and offered for sale at the retail price listed on attached Consignment Schedule. Agreed-upon retail price may be lowered by no more than 10%. If other discounts are given, they shall come from Agent's sales commission. Agent shall receive the following sales commission: ____ % of the retail price. The remainder of the sale price shall be paid to Artist. Artist agrees to refrain from any and all unauthorized contact and/or interference with any accounts or customer relationships and/or agreements entered into between Agent's accounts/customers for the duration of this Agreement.

5. Payment

On outright sales, Agent shall pay Artist's share within thirty (30) days after the date of sale. On installment sales, Agent shall first apply the proceeds from sale of the work to pay Artist's share. Payment shall be made within thirty (30) days after Agent's receipt of each installment until paid in full. Late payment shall be accompanied by interest calculated at the rate of _____%. Agent shall be responsible for billing all clients.

6. Delivery

All costs of delivery (including transportation and insurance) to Agent's address shall be paid by Artist. All deliveries back to Artist will be paid by Agent.

7. Title & Receipt

Artist warrants that he/she created and possesses unencumbered title to all works of art consigned to Agent under this Agreement. Title to the consigned work shall remain with Artist until he/she is paid in full for any given piece of art. Agent acknowledges receipt of the works described on the Consignment Schedule.

8. Sales Price

Agent shall sell the consigned works at the retail price asked by Artist and specified in writing on the Consignment Schedule. Agent shall have discretion to vary the agreed price by 10%.

9. Loss or Damage

Agent shall not intentionally commit or authorize any physical defacement, mutilation, alteration, or destruction of any of the consigned works. Agent shall be responsible for the proper cleaning, maintenance, and protection of consigned works, and shall also be responsible for the loss or damage of consigned works, whether the work be on the Agent's premises, on loan, on approval, on rental/lease or otherwise removed from his premises.

10. Statements of Account

Agent shall give Artist a Statement of Account within fifteen (15) days after the end of each calendar quarter beginning _____. The Statement of Account shall include the works sold or rented, date, price, and terms of sale or rental, commission due to Artist, name and address of each purchaser or renter, and location of all unsold works. Agent warrants that the Statement of Account shall be accurate and complete in all respects. Artist (or his/her authorized representatives) shall have the right to inspect the financial records of Agent

pertaining to any transaction involving Artist's work. Agent shall keep the books and records at Agent's place of business and Artist may make inspection during normal business hours on the giving of reasonable notice, no more than twice a year.

11. Contract for Sale

Artist and Agent shall agree on the appropriate form of contracts for sale of Artist's work to third parties.

12. Copyright

Artist reserves all reproduction rights on all works consigned to Agent. No work may be reproduced by Agent without the prior written approval of Artist. All approved reproductions in catalogs, brochures, advertisements, and other promotional literature shall carry the following notice: "Title" by (name of Artist) and year of artwork.

13. Duration of Agreement

This Agreement shall commence upon the date of signing and shall continue in effect until the _____ day of _____, 20___ . Either party may terminate Agreement by giving thirty (30) days prior written notice. If terminated by Artist, Agent continues to receive "royalties" of ___ % on all sales for a _____ period in association with work originally obtained. If Agent dissolves agreement, Agent owes Artist a gross figure to bring Artist's yearly earnings up to previous year's earnings. If yearly gross income is not less than previous year, Agent owes Artist nothing. Agent relinquishes all rights to commissions except for 5% royalty on all sales or resales associated with Agent's original negotiations. Artist agrees to refrain from entering into any agreements with Agent-received accounts for a period of 18 months after the term of this Agreement. However, Artist may enter into a direct relationship with Agent's established accounts and customers within this 18 months with the express written approval and consent of Agent, provided that Artist pays to Agent the commission that would have been charged under the terms and conditions of this Agreement had this Agreement remained in full force.

14. Assignment

This Agreement shall not be assigned by either of the parties hereto. It shall be binding on and inure to the benefit of the successors, administrators, executors, or heirs of Agent and Artist.

15. Independent Contractor Status

Both parties agree that the Agent is acting as an independent contractor. This Agreement is not an employment agreement, nor does it constitute a joint venture or partnership between Artist and Agent.

16. Return of Works

Agent shall be responsible for return of all works not sold upon termination of this Agreement. All costs of return, including transportation and insurance, shall be paid as follows: __ % by Artist, if Artist dissolves; __% by Agent, if Agent dissolves.

17. Arbitration

All disputes arising out of this Agreement shall be submitted to final and binding arbitration. The arbitrator shall be selected in accordance with the rules of Arbitration and Mediation Services. The arbitrator's award shall be final, and judgment may be entered upon it by any court having jurisdiction thereof.

18. Entire Agreement

This Agreement represents the entire agreement between Artist and Agent and supersedes all prior negotiations, representations and agreements whether oral or written. This Agreement may only be amended by a written instrument signed by both parties.

19. Governing Law

This Agreement shall be governed by the laws of the State of _____.

IN WITNESS WHEREOF the parties hereto have executed this Agreement on the day and year first above written.

ARTIST _____ DATE _____

AGENT _____ DATE _____

Form VA

Detach and read these instructions before completing this form.
Make sure all applicable spaces have been filled in before you return this form.

When to Use This Form: Use Form VA for copyright registration of published or unpublished works of the visual arts. This category consists of "pictorial, graphic, or sculptural works," including two-dimensional and three-dimensional works of fine, graphic, and applied art, photographs, prints and art reproductions, maps, globes, charts, technical drawings, diagrams, and models.

What Does Copyright Protect? Copyright in a work of the visual arts protects those pictorial, graphic, (or sculptural elements that, either alone or in combination, represent an "original work of authorship." The statute declares: "In no case does copyright protection for an original work of authorship extend to any idea, procedure, process, system, method of operation, concept, principle, or discovery, regardless of the form in which it is described, explained, illustrated, or embodied in such work."

Works of Artistic Craftsmanship and Designs: "Works of artistic craftsmanship" are registrable on Form VA, but the statute makes clear that protection extends to "their form" and not to "their mechanical or utilitarian aspects." The "design of a useful article" is considered copyrightable "only if, and only to the extent that, such design incorporates pictorial, graphic, or sculptural features that can be identified separately from, and are capable of existing independently of, the utilitarian aspects of the article."

Labels and Advertisements: Works prepared for use in connection with the sale or advertisement of goods and services are registrable if they contain "original work of authorship." Use Form VA if the copyrightable material in the work you are registering is mainly pictorial or graphic; use Form TX if it consists mainly of text. **Note:** Words and short phrases such as names, titles, and slogans cannot be protected by copyright, and the same is true of standard symbols, emblems, and other commonly used graphic designs that are in the public domain. When used commercially, material of that sort can sometimes be protected under state laws of unfair competition or under the federal trademark laws. For information about trademark registration, write to the U.S. Patent and Trademark Office, PO Box 1450, Alexandria, VA 22313-1450.

Architectural Works: Copyright protection extends to the design of buildings created for the use of human beings. Architectural works created on or after December 1, 1990, or that on December 1, 1990, were unconstructed and embodied only in unpublished plans or drawings are eligible. Request Circular 41, *Copyright Claims in Architectural Works*, for more information. Architectural works and technical drawings cannot be registered on the same application.

Deposit to Accompany Application: An application for copyright registration must be accompanied by a deposit consisting of copies representing the entire work for which registration is to be made.

Unpublished Work: Deposit one complete copy.

Published Work: Deposit two complete copies of the best edition.

Work First Published Outside the United States: Deposit one complete copy of the first foreign edition.

Contribution to a Collective Work: Deposit one complete copy of the best edition of the collective work.

The Copyright Notice: Before March 1, 1989, the use of copyright notice was mandatory on all published works, and any work first published before that date should have carried a notice. For works first published on and after March 1, 1989, use of the copyright notice is optional. For more information about copyright notice, see Circular 3, *Copyright Notice*.

For Further Information: To speak to a Copyright Office staff member, call (202) 707-3000 (TTY: (202) 707-6737). Recorded information is available 24 hours a day. Order forms and other publications from the address in space 9 or call the Forms and Publications Hotline at (202) 707-9100. Access and download circulars, forms, and other information from the Copyright Office website at *www.copyright.gov*.

Please type or print using black ink. The form is used to produce the certificate.

SPACE 1: Title

Title of This Work: Every work submitted for copyright registration must be given a title to identify that particular work. If the copies of the work bear a title (or an identifying phrase that could serve as a title), transcribe that wording *completely* and *exactly* on the application. Indexing of the registration and future identification of the work will depend on the information you give here. For an architectural work that has been constructed, add the date of construction after the title; if unconstructed at this time, add "not yet constructed."

Publication as a Contribution: If the work being registered is a contribution to a periodical, serial, or collection, give the title of the contribution in the "Title of This Work" space. Then, in the line headed "Publication as a Contribution," give information about the collective work in which the contribution appeared.

Nature of This Work: Briefly describe the general nature or character of the pictorial, graphic, or sculptural work being registered for copyright. Examples: "Oil Painting"; "Charcoal Drawing"; "Etching"; "Sculpture"; "Map"; "Photograph"; "Scale Model"; "Lithographic Print"; "Jewelry Design"; "Fabric Design."

Previous or Alternative Titles: Complete this space if there are any additional titles for the work under which someone searching for the registration might be likely to look, or under which a document pertaining to the work might be recorded.

SPACE 2: Author(s)

General Instruction: After reading these instructions, decide who are the "authors" of this work for copyright purposes. Then, unless the work is a "collective work," give the requested information about every "author" who contributed any appreciable amount of copyrightable matter to this version of the work. If you need further space, request Continuation Sheets. In the case of a collective work, such as a catalog of paintings or collection of cartoons by various authors, give information about the author of the collective work as a whole.

Name of Author: The fullest form of the author's name should be given. Unless the work was "made for hire," the individual who actually created the work is its "author." In the case of a work made for hire, the statute provides that "the employer or other person for whom the work was prepared is considered the author."

What Is a "Work Made for Hire"? A "work made for hire" is defined as: (1) "a work prepared by an employee within the scope of his or her employment"; or (2) "a work specially ordered or commissioned for use as a contribution to a collective work, as a part of a motion picture or other audiovisual work, as a translation, as a supplementary work, as a compilation, as an instructional text, as a test, as answer material for a test, or as an atlas, if the parties expressly agree in a written instrument signed by them that the work shall be considered a work made for hire." If you have checked "Yes" to indicate that the work was "made for hire," you must give the full legal name of the employer (or other person for whom the work was prepared). You may also include the name of the employee along with the name of the employer (for example: "Elster Publishing Co., employer for hire of John Ferguson").

"Anonymous" or "Pseudonymous" Work: An author's contribution to a work is "anonymous" if that author is not identified on the copies or phonorecords of the work. An author's contribution to a work is "pseudonymous" if that author is identified on the copies or phonorecords under a fictitious name. If the work is "anonymous" you may: (1) leave the line blank; or (2) state "anonymous" on the line; or (3) reveal the author's identity. If the work is "pseudonymous" you may: (1) leave the line blank; or (2) give the pseudonym and identify it as such (for example: "Huntley Haverstock, pseudonym"); or (3) reveal the author's name, making clear which is the real name and which is the pseudonym (for example: "Henry Leek, whose pseudonym is Priam Farrel"). However, the citizenship or domicile of the author *must* be given in all cases.

Dates of Birth and Death: If the author is dead, the statute requires that the year of death be included in the application unless the work is anonymous or pseudonymous. The author's birth date is optional but is useful as a form of identification. Leave this space blank if the author's contribution was a "work made for hire."

Author's Nationality or Domicile: Give the country of which the author is a citizen or the country in which the author is domiciled. Nationality or domicile *must* be given in all cases.

Nature of Authorship: Catagories of pictorial, graphic, and sculptural authorship are listed below. Check the box(es) that best describe(s) each author's contribution to the work.

3-Dimensional sculptures: fine art sculptures, toys, dolls, scale models, and sculptural designs applied to useful articles.

2-Dimensional artwork: watercolor and oil paintings; pen and ink drawings; logo illustrations; greeting cards; collages; stencils; patterns; computer graphics; graphics appearing in screen displays; artwork appearing on posters, calendars, games, commercial prints and labels, and packaging, as well as 2-dimensional artwork applied to useful articles, and designs reproduced on textiles, lace, and other fabrics; on wallpaper, carpeting, floor tile, wrapping paper, and clothing.

Reproductions of works of art: reproductions of preexisting artwork made by, for example, lithography, photoengraving, or etching.

Maps: cartographic representations of an area, such as state and county maps, atlases, marine charts, relief maps, and globes.

Photographs: pictorial photographic prints and slides and holograms.

Jewelry designs: 3-dimensional designs applied to rings, pendants, earrings, necklaces, and the like.

Technical drawings: diagrams illustrating scientific or technical information in linear form, such as architectural blueprints or mechanical drawings.

Text: textual material that accompanies pictorial, graphic, or sculptural works, such as comic strips, greeting cards, games rules, commercial prints or labels, and maps.

Architectural works: designs of buildings, including the overall form as well as the arrangement and composition of spaces and elements of the design.

NOTE: Any registration for the underlying architectural plans must be applied for on a separate Form VA, checking the box "Technical drawing."

3 SPACE 3: Creation and Publication

General Instructions: Do not confuse "creation" with "publication." Every application for copyright registration must state "the year in which creation of the work was completed." Give the date and nation of first publication only if the work has been published.

Creation: Under the statute, a work is "created" when it is fixed in a copy or phonorecord for the first time. Where a work has been prepared over a period of time, the part of the work existing in fixed form on a particular date constitutes the created work on that date. The date you give here should be the year in which the author completed the particular version for which registration is now being sought, even if other versions exist or if further changes or additions are planned.

Publication: The statute defines "publication" as "the distribution of copies or phonorecords of a work to the public by sale or other transfer of ownership, or by rental, lease, or lending"; a work is also "published" if there has been an "offering to distribute copies or phonorecords to a group of persons for purposes of further distribution, public performance, or public display." Give the full date (month, day, year) when, and the country where, publication first occurred. If first publication took place simultaneously in the United States and other countries, it is sufficient to state "U.S.A."

4 SPACE 4: Claimant(s)

Name(s) and Address(es) of Copyright Claimant(s): Give the name(s) and address(es) of the copyright claimant(s) in this work even if the claimant is the same as the author. Copyright in a work belongs initially to the author of the work (including, in the case of a work make for hire, the employer or other person for whom the work was prepared). The copyright claimant is either the author of the work or a person or organization to whom the copyright initially belonging to the author has been transferred.

Transfer: The statute provides that, if the copyright claimant is not the author, the application for registration must contain "a brief statement of how the claimant obtained ownership of the copyright." If any copyright claimant named in space 4 is not an author named in space 2, give a brief statement explaining how the claimant(s) obtained ownership of the copyright. Examples: "By written contract"; "Transfer of all rights by author"; "Assignment"; "By will." Do not attach transfer documents or other attachments or riders.

5 SPACE 5: Previous Registration

General Instructions: The questions in space 5 are intended to find out whether an earlier registration has been made for this work and, if so, whether there is any basis for a new registration. As a rule, only one basic copyright registration can be made for the same version of a particular work.

Same Version: If this version is substantially the same as the work covered by a previous registration, a second registration is not generally possible unless: (1) the work has been registered in unpublished form and a second registration is now being sought to cover this first published edition; or (2) someone other than the author is identified as a copyright claimant in the earlier registration, and the author is now seeking registration in his or her own name. If either of these two exceptions applies, check the appropriate box and give the earlier registration number and date. Otherwise, do not submit Form VA; instead, write the Copyright Office for information about supplementary registration or recordation of transfers of copyright ownership.

Changed Version: If the work has been changed and you are now seeking registration to cover the additions or revisions, check the last box in space 5, give the earlier registration number and date, and complete both parts of space 6 in accordance with the instruction below.

Previous Registration Number and Date: If more than one previous registration has been made for the work, give the number and date of the latest registration.

6 SPACE 6: Derivative Work or Compilation

General Instructions: Complete space 6 if this work is a "changed version," "compilation," or "derivative work," and if it incorporates one or more earlier works that have already been published or registered for copyright, or that have fallen into the public domain. A "compilation" is defined as "a work formed by the collection and assembling of preexisting materials or of data that are selected, coordinated, or arranged in such a way that the resulting work as a whole constitutes an original work of authorship." A "derivative work" is "a work based on one or more preexisting works." Examples of derivative works include reproductions of works of art, sculptures based on drawings, lithographs based on paintings, maps based on previously published sources, or "any other form in which a work may be recast, transformed, or adapted." Derivative works also include works "consisting of editorial revisions, annotations, or other modifications" if these changes, as a whole, represent an original work of authorship.

Preexisting Material (space 6a): Complete this space *and* space 6b for derivative works. In this space identify the preexisting work that has been recast, transformed, or adapted. Examples of preexisting material might be "Grunewald Altarpiece" or "19th century quilt design." Do not complete this space for compilations.

Material Added to This Work (space 6b): Give a brief, general statement of the *additional* new material covered by the copyright claim for which registration is sought. In the case of a derivative work, identify this new material. Examples: "Adaptation of design and additional artistic work"; "Reproduction of painting by photolithography"; "Additional cartographic material"; "Compilation of photographs." If the work is a compilation, give a brief, general statement describing both the material that has been compiled *and* the compilation itself. Example: "Compilation of 19th century political cartoons."

7, 8, 9 SPACE 7, 8, 9: Fee, Correspondence, Certification, Return Address

Deposit Account: If you maintain a Deposit Account in the Copyright Office, identify it in space 7a. Otherwise, leave the space blank and send the fee with your application and deposit.

Correspondence (space 7b): Give the name, address, area code, telephone number, email address, and fax number (if available) of the person to be consulted if correspondence about this application becomes necessary.

Certification (space 8): The application cannot be accepted unless it bears the date and the *handwritten signature* of the author or other copyright claimant, or of the owner of exclusive right(s), or of the duly authorized agent of the author, claimant, or owner of exclusive right(s).

Address for Return of Certificate (space 9): The address box must be completed legibly since the certificate will be returned in a window envelope.

Form VA
For a Work of the Visual Arts
UNITED STATES COPYRIGHT OFFICE

REGISTRATION NUMBER

| VA | VAU |

EFFECTIVE DATE OF REGISTRATION

| Month | Day | Year |

DO NOT WRITE ABOVE THIS LINE. IF YOU NEED MORE SPACE, USE A SEPARATE CONTINUATION SHEET.

1

Title of This Work ▼ NATURE OF THIS WORK ▼ See instructions

Previous or Alternative Titles ▼

Publication as a Contribution If this work was published as a contribution to a periodical, serial, or collection, give information about the collective work in which the contribution appeared. **Title of Collective Work ▼**

If published in a periodical or serial give: **Volume ▼** **Number ▼** **Issue Date ▼** **On Pages ▼**

2

a NAME OF AUTHOR ▼ DATES OF BIRTH AND DEATH
Year Born ▼ Year Died ▼

NOTE

Under the law, the "author" of a "work made for hire" is generally the employer, not the employee (see instructions). For any part of this work that was "made for hire" check "Yes" in the space provided, give the employer (or other person for whom the work was prepared) as "Author" of that part, and leave the space for dates of birth and death blank.

Was this contribution to the work a "work made for hire"?
☐ Yes
☐ No

Author's Nationality or Domicile
Name of Country
OR { Citizen of _____
Domiciled in _____

Was This Author's Contribution to the Work
Anonymous? ☐ Yes ☐ No
Pseudonymous? ☐ Yes ☐ No

If the answer to either of these questions is "Yes," see detailed instructions.

Nature of Authorship Check appropriate box(es). **See instructions**
☐ 3-Dimensional sculpture ☐ Map ☐ Technical drawing
☐ 2-Dimensional artwork ☐ Photograph ☐ Text
☐ Reproduction of work of art ☐ Jewelry design ☐ Architectural work

b Name of Author ▼ Dates of Birth and Death
Year Born ▼ Year Died ▼

Was this contribution to the work a "work made for hire"?
☐ Yes
☐ No

Author's Nationality or Domicile
Name of Country
OR { Citizen of _____
Domiciled in _____

Was This Author's Contribution to the Work
Anonymous? ☐ Yes ☐ No
Pseudonymous? ☐ Yes ☐ No

If the answer to either of these questions is "Yes," see detailed instructions.

Nature of Authorship Check appropriate box(es). **See instructions**
☐ 3-Dimensional sculpture ☐ Map ☐ Technical drawing
☐ 2-Dimensional artwork ☐ Photograph ☐ Text
☐ Reproduction of work of art ☐ Jewelry design ☐ Architectural work

3

a Year in Which Creation of This Work Was Completed
_____ Year
This information must be given in all cases.

b Date and Nation of First Publication of This Particular Work
Complete this information ONLY if this work has been published.
Month _____ Day _____ Year _____
_____ Nation

4

See instructions before completing this space.

COPYRIGHT CLAIMANT(S) Name and address must be given even if the claimant is the same as the author given in space 2. ▼

Transfer If the claimant(s) named here in space 4 is (are) different from the author(s) named in space 2, give a brief statement of how the claimant(s) obtained ownership of the copyright. ▼

DO NOT WRITE HERE OFFICE USE ONLY

APPLICATION RECEIVED

ONE DEPOSIT RECEIVED

TWO DEPOSITS RECEIVED

FUNDS RECEIVED

DO NOT WRITE ABOVE THIS LINE. IF YOU NEED MORE SPACE, USE A SEPARATE CONTINUATION SHEET.

PREVIOUS REGISTRATION Has registration for this work, or for an earlier version of this work, already been made in the Copyright Office?

☐ **Yes** ☐ **No** If your answer is "Yes," why is another registration being sought? (Check appropriate box.) ▼

a. ☐ This is the first published edition of a work previously registered in unpublished form.

b. ☐ This is the first application submitted by this author as copyright claimant.

c. ☐ This is a changed version of the work, as shown by space 6 on this application.

If your answer is "Yes," give: **Previous Registration Number** ▼ **Year of Registration** ▼

5

DERIVATIVE WORK OR COMPILATION Complete both space 6a and 6b for a derivative work; complete only 6b for a compilation.
a. Preexisting Material Identify any preexisting work or works that this work is based on or incorporates. ▼

b. Material Added to This Work Give a brief, general statement of the material that has been added to this work and in which copyright is claimed. ▼

6
a
b
See instructions
before completing
this space.

DEPOSIT ACCOUNT If the registration fee is to be charged to a Deposit Account established in the Copyright Office, give name and number of Account.
Name ▼ **Account Number** ▼

7
a

CORRESPONDENCE Give name and address to which correspondence about this application should be sent. Name/Address/Apt/City/State/Zip ▼

b

Area code and daytime telephone number () Fax number ()

Email

CERTIFICATION* I, the undersigned, hereby certify that I am the

check only one ▶ {
☐ author
☐ other copyright claimant
☐ owner of exclusive right(s)
☐ authorized agent of _____
}
Name of author or other copyright claimant, or owner of exclusive right(s) ▲

8

of the work identified in this application and that the statements made by me in this application are correct to the best of my knowledge.

Typed or printed name and date ▼ If this application gives a date of publication in space 3, do not sign and submit it before that date.

_____ Date _____

Handwritten signature (X) ▼

X _____

Certificate will be mailed in window envelope to this address:	Name ▼
	Number/Street/Apt ▼
	City/State/ZIP ▼

9

*17 *USC* §506(e): Any person who knowingly makes a false representation of a material fact in the application for copyright registration provided for by section 409, or in any written statement filed in connection with the application, shall be fined not more than $2,500.

Form VA Rev: 07/2006 Print: 07/2006—30,000 Printed on recycled paper U.S. Government Printing Office: 2004-320-958/60,126

 # Instructions for Short Form VA

For pictorial, graphic, and sculptural works

USE THIS FORM IF—
1. You are the *only* author and copyright owner of this work, *and*
2. The work was *not* made for hire, *and*
3. The work is completely new (does not contain a substantial amount of material that has been previously published or registered or is in the public domain).

If any of the above does not apply, you must use standard Form VA.

NOTE: *Short Form VA is not appropriate for an anonymous author who does not wish to reveal his or her identity.*

HOW TO COMPLETE SHORT FORM VA
- Type or print in black ink.
- Be clear and legible. (Your certificate of registration will be copied from your form.)
- Give only the information requested.

Note: You may use a continuation sheet (Form __/CON) to list individual titles in a collection. Complete Space A and list the individual titles under Space C on the back page. Space B is not applicable to short forms.

1 Title of This Work

You must give a title. If there is no title, state "UNTITLED." If you are registering an unpublished collection, give the collection title you want to appear in our records (for example: "Jewelry by Josephine, 1995 Volume"). Alternative title: If the work is known by two titles, you also may give the second title. If the work has been published as part of a larger work (including a periodical), give the title of that larger work instead of an alternative title, in addition to the title of the contribution.

2 Name and Address of Author and Owner of the Copyright

Give your name and mailing address. You may include your pseudonym followed by "pseud." Also, give the nation of which you are a citizen or where you have your domicile (i.e., permanent residence).
Give daytime phone and fax numbers and email address, if available.

3 Year of Creation

Give the latest year in which you completed the work you are registering at this time. A work is "created" when it is "fixed" in a tangible form. Examples: drawn on paper, molded in clay, stored in a computer.

4 Publication

If the work has been published (i.e., if copies have been distributed to the public), give the complete date of publication (month, day, and year) and the nation where the publication first took place.

5 Type of Authorship in This Work

Check the box or boxes that describe your authorship in the material you are sending. For example, if you are registering illustrations but have not written the story yet, check only the box for "2-dimensional artwork."

6 Signature of Author

Sign the application in black ink and check the appropriate box. The person signing the application should be the author or his/her authorized agent.

7 Person to Contact for Rights/Permissions

This space is optional. You may give the name and address of the person or organization to contact for permission to use the work. You may also provide phone, fax, or email information.

8 Certificate Will Be Mailed

This space must be completed. Your certificate of registration will be mailed in a window envelope to this address. Also, if the Copyright Office needs to contact you, we will write to this address.

9 Deposit Account

Complete this space only if you currently maintain a deposit account in the Copyright Office.

MAIL WITH THE FORM

- The filing fee in the form of a check or money order (*no cash*) payable to *Register of Copyrights*. (Copyright Office fees are subject to change. For current fees, check the Copyright Office website at *www.copyright.gov*, write the Copyright Office, or call (202) 707-3000.) — *and*
- One or two copies of the work or identifying material consisting of photographs or drawings showing the work. See table (right) for requirements for most works. **Note:** Request Circular 40a for information about the requirements for other works. Copies submitted become the property of the U.S. Government.

Mail everything (application form, copy or copies, and fee) *in one package* to:

*Library of Congress
Copyright Office
101 Independence Avenue SE
Washington, DC 20559-6000*

Questions? Call (202) 707-3000 [TTY: (202) 707-6737] between 8:30 a.m. and 5:00 p.m. eastern time, Monday through Friday except federal holidays. For forms and informational circulars, call (202) 707-9100 24 hours a day, 7 days a week, or download them from the Copyright Office website at *www.copyright.gov*.

If you are registering:	And the work is *unpublished/published* send:
• 2-dimensional artwork in a book, map, poster, or print	a. And the work is *unpublished*, send one complete copy or identifying material b. And the work is *published*, send two copies of the best published edition
• 3-dimensional sculpture, • 2-dimensional artwork applied to a T-shirt	a. And the work is *unpublished*, send identifying material b. And the work is *published*, send identifying material
• a greeting card, pattern, commercial print or label, fabric, wallpaper	a. And the work is *unpublished*, send one complete copy or identifying material b. And the work is *published*, send one copy of the best published edition

Short Form VA
For a Work of the Visual Arts
UNITED STATES COPYRIGHT OFFICE

REGISTRATION NUMBER

VA	VAU

Effective Date of Registration

Application Received

Examined By

Deposit Received	
One	Two

Correspondence ❑ Fee Received

TYPE OR PRINT IN BLACK INK. DO NOT WRITE ABOVE THIS LINE.

1 **Title of This Work:**

Alternative title or title of larger work in which this work was published:

2 **Name and Address of Author and Owner of the Copyright:**

Nationality or domicile:
Phone, fax, and email:

Phone () Fax ()
Email

3 **Year of Creation:**

4 **If work has been published, Date and Nation of Publication:**

a. Date _____ _____ _____ *(Month, day, and year all required)*
 Month Day Year

b. Nation

5 **Type of Authorship in This Work:**
Check all that this author created.

❑ 3-Dimensional sculpture ❑ Photograph ❑ Map
❑ 2-Dimensional artwork ❑ Jewelry design ❑ Text
❑ Technical drawing

6 **Signature:**

Registration cannot be completed without a signature.

I certify that the statements made by me in this application are correct to the best of my knowledge. * Check one:

❑ Author ❑ Authorized agent

X _

OPTIONAL

7 **Name and Address of Person to Contact for Rights and Permissions:**
Phone, fax, and email:

❑ Check here if same as #2 above.

Phone () Fax ()
Email

8
Certificate will be mailed in window envelope to this address:

Name ▼

Number/Street/Apt ▼

City/State/ZIP ▼

9 *Complete this space only if you currently hold a Deposit Account in the Copyright Office.*

Deposit Account #_____
Name _____

DO NOT WRITE HERE Page 1 of _____ pages

Form VA-Short Rev: 07/2006 Print: 07/2006—30,000 Printed on recycled paper

U.S. Government Printing Office: 2005-320-958/60,126

Inventory

- ### MASTER INVENTORY
 Each time you start an artwork, assign a new code # and note it on this form. A code number could be 010599, standing for January 5, 2007.

- ### HISTORICAL DOCUMENTATION OF ORIGINALS
 Likewise, use this form for each artwork's history.

- ### HISTORICAL DOCUMENTATION OF PRINTS
 Each print, limited edition, giclée, card edition, etc., should have its own historical data sheet.

- ### ARTWORK OUT
 Keep a record of each original artwork that leaves your studio. This record often will match your consignment records. You should also keep track of rentals, exhibitions, loans—any circumstance when your artwork leaves your possession. Have a signed piece of paper confirming each piece that is taken from your studio. Keep all these in one part of your three-ring binder, available for easy reference.

- ### SLIDE REFERENCE SHEET
 This sheet corresponds to the 20 slots of a slide sleeve. Put the title of the artwork in each slot. It also serves as a record of where slides were sent. Attach a copy of this to each slide sleeve you send out. Keep a photocopy for your own records.

- ### IMAGES SENT OUT
 Keep track of where you send your work for review so you can remember to follow up with a call.

- ### COMPETITION RECORD
 Keep track of competitions you enter.

- ### EXHIBITIONS/COMPETITIONS
 This sheet provides you with a comprehensive overview of the exhibitions and competitions you've entered. Keeping this information up-to-date allows you to update your resume easily.

- ### ITEM REQUEST RECORD
 Use this form to remind yourself when you send away for a prospectus, information on supplies, or any item you request by mail, telephone or e-mail.

MASTER INVENTORY

CODE#	TITLE	MED	SIZE	STARTED	FINISHED	SOLD	PRICE	LOCATION

HISTORICAL DOCUMENTATION OF ORIGINALS

Code # _____ Title _____

Date begun _____ Date completed _____ Hours to complete _____

Price/framed _____ Price/unframed _____ Other costs _____

Size/framed _____ Size/unframed _____

Medium _____

Colors _____

Design description _____ Place photo of
image here

Inspiration _____

Techniques used in execution _____

Materials used in framing _____

Recommendations for care _____

EXHIBITION HISTORY

Date	Location	Date returned

PURCHASE HISTORY

Date sold _____ Cost _____

Sold to _____

Second owner _____ Date sold _____ Price _____

HISTORICAL DOCUMENTATION OF PRINTS

Inventory # _____ Title _____

Date printed _____ Quantity printed _____ Signed copies _____

Price/framed _____ Price/unframed _____

Printing info _____ Size/unframed _____

Other info _____

PURCHASERS

1. _____
2. _____
3. _____
4. _____
5. _____
6. _____
7. _____
8. _____
9. _____
10. _____
11. _____
12. _____
13. _____
14. _____
15. _____

ARTWORK OUT

DATE	CODE #	TITLE	LOCATION	RETURNED	RESULT

SLIDE REFERENCE SHEET

Sent to _____ on _____

1	2	3	4
5	6	7	8
9	10	11	12
13	14	15	16
17	18	19	20

IMAGES SENT OUT

DATE SENT	LOCATION	ITEM	VIA	RETURNED	RESULT

COMPETITION RECORD

Competition name _____ Closing date _____ Fee _____

Date applied _____ Juried/non-juried _____ Accepted/rejected _____

Artwork sent _____

Juror name(s) _____

1st Prize _____ 2nd Prize _____ 3rd Prize _____

Comments _____

Competition name _____ Closing date _____ Fee _____

Date applied _____ Juried/non-juried _____ Accepted/rejected _____

Artwork sent _____

Juror name(s) _____

1st Prize _____ 2nd Prize _____ 3rd Prize _____

Comments _____

Competition name _____ Closing date _____ Fee _____

Date applied _____ Juried/non-juried _____ Accepted/rejected _____

Artwork sent _____

Juror name(s) _____

1st Prize _____ 2nd Prize _____ 3rd Prize _____

Comments _____

EXHIBITIONS/COMPETITIONS

EXHIBITION	DATE	DUE	FEE	DATE SENT	RESULTS

ITEM REQUEST RECORD

DATE	ITEM REQUESTED	NAME/ ADDRESS	TELEPHONE	DATE REC'D

Customers

- ### WHO IS ATTRACTED TO MY ARTWORK?
 Fill this out and study your answers to gain insight regarding where to concentrate your marketing efforts.

- ### CUSTOMER PROFILE
 Another format, similar to the previous one, that will help you decipher your target market.

- ### CUSTOMER/CLIENT RECORD
 Keep a record for each client as well as each potential client. File these alphabetically in your three-ring binder. When one of these people calls, turn to his/her page so you'll remember who he is, what he needs, color preferences, etc.

- ### PHONE-ZONE SHEET
 Use this form to keep track of important phone calls you make to prospective and current clients. It will remind you to follow up. File this next to the Customer/Client Record.

- ### MAILING LIST SIGN-UP SHEET
 Put this out at your next Open Studio or show for interested parties to sign. Add these names to your in-house mailing list. Mail to them at least twice a year; perhaps a postcard, invitation to an exhibition, Christmas card with a photo of your latest creation or just a friendly note.

WHO IS ATTRACTED TO MY ARTWORK?

❏ Men ❏ Women ❏ Children ❏ All

Marital status: _____

Ethnic background: _____

Age group: _____

Religion: _____

Living environment: _____

Income level: _____

Education level: _____

How are they like me? _____

How are they different? _____

Values/tastes: _____

What do they read?_____

Impression I want to make? _____

Where do they hang out?_____

Where or how am I most likely to get their attention?

Potential clients in order of priority:_____

What are their reasons for buying my art? _____

What organizations do they belong to?_____

Specific region of the country to sell to? _____

Describe exactly what I am selling: _____

Define more specifically my target market: _____

Features of my artwork: _____

Who is my competition? _____

What can I learn from my competitors? _____

Benefits to buyer. Can I offer something more, something different, something better than my competitors?

Experience, authority, expertise. Why would someone trust me? _____

How will buying my artwork make the customer's life better? _____

How can people pay for their purchase (credit card, check, terms)? Will this satisfy my target market?

Am I able to produce enough original pieces for potential buyers in my target market? _____

Are there any legal considerations in selling my product to this (or any other) market? _____

CUSTOMER PROFILE

DEMOGRAPHICS

Mostly male/female

Age

Education level

Income level

Single/married/divorced

Children/grandchildren

Occupation/profession

Religion

Ethnic background

GEOGRAPHICS

Lives in city/suburb/rural

Rents/owns/type of building

Type of living environment

Groups/associations/clubs

Hobbies/leisure time activities

Shops where: stores/catalogs/online

PSYCHOGRAPHICS

Lifestyle

Perceived social status

Knowledge of art

Favorite magazine

Personal attitudes

Personal values

Special beliefs

Unique tastes

How they are like me

How they are different from me

Shops how: cash/credit

My consumer is (describe a person):

CUSTOMER/CLIENT RECORD

Name _____

Address _____

Work phone _____ Home phone _____ Age _____

Referred by _____

BACKGROUND INFORMATION

Single/married/divorced _____ Spouse's name and age _____

Children and ages _____

Pets _____

Occupation _____

Education/income level _____

Type of furnishing/home style _____

ART PREFERENCES

Subject matter _____ Colors _____

Style/type of work _____ Size/medium preferred _____

Needs/wants _____

Intended use _____

IMPRESSIONS AND COMMENTS

Last contact date by phone _____

Last mailing _____

Needs information on _____

Other follow-up needs _____

PURCHASES

DATE	PRICE	SIZE	MEDIUM	TITLE/DESCRIPTION	USE

PHONE-ZONE SHEET

Name _____

Address _____

City/State/Zip _____

Phone _____

Fax _____

Personal details _____

Art interest _____

DATE	TIME	PHONE/LETTER/CALL	NOTES	FOLLOW-UP

MAILING LIST SIGN-UP SHEET

NAME	ADDRESS	CITY	STATE	ZIP	TELEPHONE	E-MAIL
1.						
2.						
3.						
4.						
5.						
6.						
7.						
8.						
9.						
10.						
11.						
12.						
13.						
14.						
15.						
16.						
17.						
18.						
19.						
20.						
21.						
22.						

Marketing Plans

- **SAMPLE MARKETING PLAN**
 This sample will help you think about what your personal plan could contain.

- **MARKETING PLAN**
 You should reanalyze this every six months. Keep copies of your old ones handy in your three-ring binder so you can see how you've grown and changed in your plans.

- **FIVE-YEAR GOALS**
 Take the previous form—Marketing Plan—and break it down into a practical five-year plan. You will need to work and rework this as time goes by. Keep copies so you can study how your intentions have changed.

- **TWELVE-MONTH GOALS**
 Break down your five-year goals into smaller ones on this twelve-month plan. Be specific.

- **PROJECT PLANNER**
 Take any given project from your above goals and use this form to keep it moving at a good pace.

- **PROJECT PROGRESS CHART**
 Another format to use to keep each project moving.

- **MONTHLY PROJECT STATUS**
 You can list six projects here and see how they are progressing.

- **SHOW PLANNING CALENDAR**
 Careful planning makes every show a success. Use this calendar with a group of artists working together, or improvise for your own solo show.

- **TWELVE-MONTH SHOW PLANNER**
 This form gives you a precise timeline for achieving a successful show.

- **EXHIBIT EXPENSE PLANNER**
 Each show needs a budget and a spending plan; otherwise, you will tend to overspend.

- **PUBLICITY PLANNING CHART**
 An overall chart to keep track of where you've tried to get publicity and where you've been successful

- **CHECKLIST FOR A JURIED SHOW**
 Applying to different shows shouldn't be done in a haphazard manner. Using this checklist will insure that each entry form you fill out is followed up.

- **PRINT PLANNING CALENDAR**
 All self-published artists should use this type of form to keep track of print projects.

SAMPLE MARKETING PLAN

General goal

Spend 10 hours a week marketing artwork.

Long-range objective

To be in 10 galleries within the next five years

To get into print within two years

Specific objective

Start holding an annual Open Studio.

Current strategies

Enter at least two juried shows.

Sell in an outdoor show.

Promotional materials

New business cards

Updated resume

Future strategy ideas

Pre-holiday group show

Teach a class.

Future promotional materials needed

Web site

MARKETING PLAN

GENERAL GOAL

LONG-RANGE OBJECTIVE

SPECIFIC OBJECTIVE

CURRENT STRATEGIES

PROMOTIONAL MATERIALS

FUTURE STRATEGY IDEAS

FUTURE PROMOTIONAL MATERIALS NEEDED

PROJECT PLANNER

Project title _____ Date _____

Goal of project _____

Target audience _____ Target date _____

Pertinent facts/comments _____

Plan of action _____

PEOPLE TO CONTACT	TELEPHONE/LETTER	FOLLOW-UP

PROJECT OUTCOME

PROJECT PROGRESS CHART

Project: _____

PEOPLE TO CONTACT	POSSIBLE ACTION	FOLLOW-UP	DEADLINES

RESULTS

MONTHLY PROJECT STATUS

PROJECT	Actively being worked on	On back burner	Completed/file closed	Abandoned

NOTES

SHOW PLANNING CALENDAR

	ASSIGNED TO	COMPLETED BY	DONE
Start a group			
Establish a leader			
Decide where to exhibit			
Pick show title			
Pieces per artist			
Expenses per artist			
Job assignments			
Confirm place			
Confirm date			
Get photos for PR			
Design invitations			
Prepare mailing list			
Prepare literature			
Send out PR			
Address and mail invitations			
Find display stands			
Label work			
Price work			
Make inventory lists			
Plan refreshments			
Get extra help			
Develop a hanging plan			
Set up sales area			
Bring extra tools			

TWELVE-MONTH SHOW PLANNER

	DATE TO BE DONE	DUTIES	DONE
12 MONTHS PRIOR			
Locate a place			
10 MONTHS PRIOR			
Decide on theme			
Plan budget			
Plan advertising			
8 MONTHS PRIOR			
Create invitation list			
6 MONTHS PRIOR			
Design invitations			
Select B&W photo for PR			
4 MONTHS PRIOR			
Frame pieces			
3 MONTHS PRIOR			
Print invitations			
Mail PR to monthly pubs			
Find salespersons			
2 MONTHS PRIOR			
Address invitations			
1 MONTH PRIOR			
Mail PR to semimonthly pubs			
Mail invitations			
Call current clients			
Plan refreshments, decorations			
2 WEEKS PRIOR			
Call press/local PR			
3 DAYS PRIOR			
Hang work			
DAY OF			
Arrive early			
FOLLOW-UP			
Dismantle			
Write thank-you notes			

EXHIBIT EXPENSE PLANNER

Name of show _____ Dates/hours of show _____

Sponsor _____

Number of pieces needed _____

Shipping/delivery instructions _____

PREPARATION

Forms _____

Packing _____

Travel arrangements _____

EXPENSES

Entry fee _____ Framing _____ Crating _____

Travel _____ Food _____ Lodging _____

Advertising _____ Brochures _____ Insurance _____

Other _____

RECORD OF SALES

Number of originals shown _____ Number of originals sold _____

Title _____ Price _____

Number of prints shown _____ Number of prints sold _____

Title _____ Price _____

Other items shown/sold _____

PUBLICITY PLANNING CHART

	IDEA/EVENT	MATERIALS NEEDED	DEADLINES
Daily newspapers			
Weekly newspapers			
Local publications			
Local magazines			
Radio			
TV			

NOTES

CHECKLIST FOR A JURIED SHOW

SHOW NAME _____

	NEEDS TO BE DONE	IN PROGRESS	DONE
PREP WORK			
Visit show the year before			
Decide to enter			
Call/get on mailing list			
APPLYING			
Decide which images to use			
Label each image correctly			
IF ACCEPTED			
Add show date to calendar			
Decide on framing			
Arrange for delivery			
Visit show			
AFTER SHOW			
Arrange to pick up unsold work			
Keep list of awards won			

PRINT PLANNING CALENDAR

Name of print _____

Proposed size and quantity _____

	DATE	ACTIVITY	NOTES	DONE
6 months		Plan painting with print sales in mind. Select appropriate subject matter.		
5 months		Test-market finished painting. Develop printing, framing and promotional budgets.		
4 months		Place printing order with printer. Order adequate promo flyers/postcards. Develop order forms.		
3 months		Arrange for framing and presentation of prints.		
2 months		Get mailing list in order.		
1 month		Mail out promo pieces. Check on framing.		
Follow-up		Stay in touch with people who purchased and those who expressed interest.		

Sample Letters

Composing a letter takes time and intentionality. A letter writer needs to put himself in the position of the recipient. What does the recipient want to know, need help with, etc.? Copy the following letters as closely as you like, but add your own style. Keep letters brief—to one page. Purchase eye-catching paper, design an interesting logo, and sign your name in a colored ink to add your personal touch.

- ## INTRODUCTION LETTER
 First time letter to a particular art world professional.

- ## QUERY TO GALLERY
 A simple, short letter or e-mail is most effective. Let your artwork do the talking.

- ## APPLICATION REQUEST
 This letter can, alternatively, be sent via e-mail.

- ## SAMPLE ISSUE REQUEST
 Educate yourself by reviewing a variety of publications. Often you can receive a complimentary copy of a publication with this type of inquiry.

- ## RESPONSE TO INQUIRY
 Keep these people on your mailing list. It takes three or more times of seeing your artwork before they'll remember you.

- ## QUERY TO BOOK PUBLISHER
 If your work is appropriate for covers or interior illustrations, contact book publishers.

- ## QUERY TO ART PUBLISHER
 It's always best if you call first to verify that a particular publisher works with the type of art you create.

- ## QUERY TO MAGAZINE EDITOR
 If you're ready for an article about your work, use this sample letter.

- ## QUERY TO INTERIOR DESIGNER
 Lots of artists have direct ties with interior designers who, essentially, act as their reps.

- ## CONFIRMATION OF SALE
 This letter is sent after a meeting at which an idea (sale, exhibit, etc.) has been agreed upon verbally. Such a letter is good legal tender in case something goes awry. Keep confirmation short and to the point.

- ## CONFIRMATION OF EXHIBITION
 This is only a confirmation of what was agreed to verbally. You will want to have a signed Exhibition Agreement also.

- ## THANK YOU FOR PURCHASE
 A thank-you note is always remembered!

- ## PRESS RELEASE
 For complete details on creating effective press releases, read *Art Marketing 101* (www.artmarketing.com).

INTRODUCTION LETTER

July 23, 2007

Evelyn Ronder
17746 Manzanita Ln
Sacramento, CA 95817

Dear Ms. Ronder,

It was nice speaking with you today. I am enclosing the following items per our conversation:
- Resumé
- Magazine articles
- Various press releases

My work can be viewed online at www.theartiste.com.

Thank you for considering being part of the group of architects, designers and serious art collectors presently making Katz an international force in the contemporary artworld.

Sincerely,

Shirley Katz

Enclosure

13672 Woodridge Ln, Westheimer, MA 02373 232.676.8732 232.676.4454 Fax

www.theartiste.com art@theartiste.com

QUERY TO GALLERY

July 23, 2007

Sanders Gallery
Evelyn Ronder
17746 Manzanita Ln
Sacramento, CA 95817

Dear Ms. Ronder,

Your gallery came to my attention during a recent visit to your city. I am requesting the opportunity to be represented by Sanders Gallery.

Please find enclosed the following:
- Resume, noting galleries and exhibits that have brought me attention
- Magazine articles
- Various press coverage that I have received due to the great interest in my work

In addition to offering original work, Katz Art has limited and open editions available. I am also agreeable to taking on custom commissions that are within my range of work.

My work can be viewed online at www.theartiste.com.

I will contact you next week to confirm that you have received this package.

Sincerely,

Shirley Katz

Enclosure

APPLICATION REQUEST

July 23, 2007

Sacramento Arts Commission
17746 Manzanita Ln
Sacramento, CA 95817

To whom it may concern:

Please send me information about and an application to the City Art Program that is funded by the Sacramento Arts Commission. I would also appreciate receiving any brochures your commission might have to familiarize myself with your association.

I have enclosed a SASE for convenience. Thank you for your time and consideration.

Sincerely,

Shirley Katz

Enclosure

SAMPLE ISSUE REQUEST

July 23, 2007

Art Now Magazine
Ad Department
17746 Manzanita Ln
Sacramento, CA 95817

Dear Staff:

Please send me a sample of your media package, including:
- Rate card (for display and classified)
- Notes on upcoming special editions
- Sample issue
- Circulation figures

If you offer special rates to new advertisers, please include that information.

Sincerely,

Shirley Katz

13672 Woodridge Ln, Westheimer, MA 02373 232.676.8732 232.676.4454 Fax

www.theartiste.com art@theartiste.com

July 23, 2007

Sanders Gallery
Evelyn Ronder
17746 Manzanita Ln
Sacramento, CA 95817

Dear Ms. Ronder,

Thank you so much for your inquiry about my new print *Abiding*. I am enclosing my resume and note cards that show this print, as well as a brochure that references other available prints.

A retail price list is also enclosed. Dealer discounts of 50% for unframed prints and 40% for framed prints, plus packaging and shipping, are available.

If you have any questions or would like to place an order, please call me at the number below or go online to www.myprints.com.

Sincerely,

Shirley Katz

Enclosure

P.S. Original works are also available!

July 23, 2007

Art Resource Ltd
Evelyn Ronder
17746 Manzanita Ln
Sacramento, CA 95817

Dear Ms. Ronder,

Please find my artwork at www.myartprints.com. I would like you to consider my work for the print market. All my pieces are available for publishing upon approval.

As you can see from my resumé, I have done quite well working with interior designers. My work is well received by the public. In their original form, my pieces are quite large—5x7 feet! Patrons continue to add originals to their collections.

I hope we can work together in the future to our mutual advantage.

Sincerely,

Shirley Katz

Enclosure

QUERY TO BOOK PUBLISHER

July 23, 2007

Art Resource Ltd
Evelyn Ronder
17746 Manzanita Ln
Sacramento, CA 95817

Dear Ms. Ronder,

Please view my artwork at www.theartiste.com. All pieces are available for publication upon approval. Per my enclosed resume, please note that I have done a number of illustrations for children's books.

I hope you will enjoy my artworks and find them unusual and motivating. In their original form, they are quite large—5x7 feet! Patrons continue to add originals to their collections.

Sincerely,

Shirley Katz

Enclosure

QUERY TO MAGAZINE EDITOR

July 23, 2007

American Artist Magazine
Stephen Doherty
17746 Manzanita Ln
Sacramento, CA 95817

Dear Mr. Doherty,

I believe your readers would be interested in a profile of my art because it is an excellent example of creating art with an ancient medium—egg tempera, a medium usually associated with medieval painters. Articles on this method garner reader attention because it is unusual.

Enclosed are three photographs of the artwork and a short explanation of how and why it was created. I've also included my resume and other select clippings to show how well my work reproduces in print.

Visit my web site at www.theartiste.com.

Sincerely,

Shirley Katz

Enclosure

13672 Woodridge Ln, Westheimer, MA 02373 232.676.8732 232.676.4454 Fax
www.theartiste.com art@theartiste.com

QUERY TO INTERIOR DESIGNER

July 23, 1007

Interiors Inc
Evelyn Ronder
17746 Manzanita Ln
Sacramento, CA 95817

Dear Ms. Ronder,

Thank you for talking with me on the phone last week. Please find enclosed the following:
- Resume
- Magazine articles
- Photo prints
- Various press releases

I hope you will become part of the group of architects, designers and serious art collectors presently making my work an international force in the contemporary artworld. Clients love the large-scale pieces (5x7 feet). To decorate around these lively pieces is a joy. See more of my work at www.theartiste.com.

I look forward to working with you in the future. I will call you next week to make sure you have received this package.

Sincerely,

Shirley Katz

13672 Woodridge Ln, Westheimer, MA 02373 232.676.8732 232.676.4454 Fax

www.theartiste.com art@theartiste.com

CONFIRMATION OF SALE

July 23, 2007

Stanley Corp
Evelyn Ronder
17746 Manzanita Ln
Sacramento, CA 95817

Dear Ms. Ronder,

This letter is to confirm our transaction of July 22, 2007 at my studio in which you agreed to purchase my original oil painting titled *Masterpiece*, measuring 5x7 feet, with a wooden frame created by me, for the sum of $2500 (exclusive of tax or shipping).

As agreed, I shall hold the painting at my studio until August 10, 2007—the date agreed upon for complete payment and transfer of the painting to Stanley Corp. At that time we shall execute a complete bill of sale.

I look forward to our next meeting.

Sincerely,

Shirley Katz

CONFIRMATION OF EXHIBITION

July 23, 2007

Melvin Gallery
Evelyn Ronder
17746 Manzanita Ln
Sacramento, CA 95817

Dear Ms. Ronder,

I am pleased that you will be showing my artwork in a four-week, one-person show in January 2009. As we discussed when we met at your office, I will be given the front three rooms in your gallery—300 square feet of wall space. You will receive the work, hand delivered, by December 26, 2008.

I am delighted that you will have an opening celebration of my exhibition for critics and patrons. As requested, I will send you my patron mailing list for you to incorporate into your existing list of 1500 patrons. I understand that my personal list will not be used for any other promotions. I understand that you will be designing, mailing and paying for the invitations.

I will be responsible for insuring the works up to the time they arrive at your gallery. From that point, they will be covered by your insurance. I will pick up the unsold pieces between February 1 and 6, 2009.

Pursuant to our agreement, you will receive a forty percent (40%) commission on all works sold during the exhibition. A Consignment Schedule will accompany my work brought to you in December, 2008, with specific titles, costs, media, sizes, etc.

Attached are two copies of an Exhibition Agreement. Please sign and return one copy.

Sincerely,

Shirley Katz

THANK YOU FOR PURCHASE

July 23, 2007

Gene Tyler
17746 Manzanita Ln
Sacramento, CA 95817

Dear Mr. Tyler,

I appreciate your interest in my artwork. I am shipping *Blue Heronry* to you today via Federal Express COD, per your request.

The price of this piece, as we agreed, is $804.38, which includes the California sales tax.

I like to inform my clients of the terms of sale as follows:

→ All works are originals, unless otherwise indicated.
→ All works are certified to be free from all defects due to faulty craftsmanship or faulty materials for a period of twelve months from date of sale. If flaws shall appear during this time, repairs shall be made by me.
→ Copyright privileges are retained by artist.

Sincerely,

Shirley Katz

P.S. I am enclosing an invitation to my Spring Show. As it is a black tie, champagne reception, please RSVP. I hope to see you there! If you'd like to bring another couple, I'll be glad to forward another invitation.

13672 Woodridge Ln, Westheimer, MA 02373 232.676.8732 232.676.4454 Fax

www.theartiste.com art@theartiste.com

PRESS PRELEASE

KATZ ART

FOR IMMEDIATE RELEASE CONTACT: SHIRLEY KATZ 232.676.8732

LOCAL ARTIST TO HOLD ONE-PERSON SHOW

Shirley Katz will exhibit 12 of her unique egg tempera paintings in a one-person show March 18-25, 2008 at Kramer's Gallery, 1854 First Avenue, Boston, MA. An opening reception honoring her will be held March 19, from 7 - 9PM, and is free and open to the public.

Katz's technical mastery of this ancient medium—egg tempera—has gained her national recognition. She won the Best of Show Award in the prestigious Masters Show in New York City in 2006, and her painting *Santa's Angels* received the Outstanding Painting Award for technical merit at the Professional Painter's Show in Dallas, Texas, that same year. Her paintings are in the collections of prominent citizens nationwide.

Egg tempera, a medium usually associated with medieval and early Renaissance painters, is essentially pure pigment suspended in a binder of egg yolk. It is an opaque paint that dries very quickly, meaning one layer of color must be "cross-hatched" over another. This helps to create the glow that egg tempera gives to artworks, making it a perfect medium for realistic scenes.

#

Biography and photographs of Shirley Katz and her award-winning works sent upon request.

13672 Woodridge Ln, Westheimer, MA 02373 232.676.8732 232.676.4454 Fax

www.theartiste.com art@theartiste.com

Sales Documents

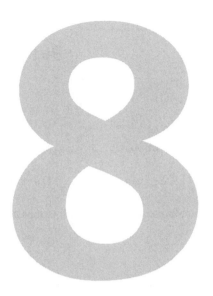

- ## PRICING WORKSHEET FOR ORIGINALS
 This form helps you calculate prices. Raise your prices slowly as you sell more and as time passes.

- ## PRICING WORKSHEET FOR LIMITED EDITIONS
 Before you print, use this form to calculate costs. This will help you figure how much your prints will need to sell for to make a profit. Guessing at pricing doesn't work!

- ## CERTIFICATE OF TITLE
 Give this Certificate to buyers of your original artwork as an added touch of professionalism.

- ## CERTIFICATE OF AUTHENTICITY
 When you are selling a limited-edition print, you want to assure your client that it is just that. Adhere this to the back of the frame so it's never misplaced.

- ## DELIVERY MEMO
 This form will help you keep track of your shipments.

- ## BILL OF SALE
 This form should be used when completing a sale to a private buyer.

- ## PROVENANCE
 Attach this to the back of your piece at the time of sale. You are explaining the history of your piece to the buyer. Remind her to give it to anyone who inherits or buys the piece at a later time.

- ## PRICE LIST
 Use this as an in-house work form.

PRICING WORKSHEET FOR ORIGINALS

Title of work _____ Code # _____

Date started _____ Date completed _____ Total hours _____ Hourly rate _____ Salary _____

Materials used in execution of piece (brand name of materials, type of paint, paper, fiber, metals, etc.) _____

Cost $ _____

Materials used in presentation (base, backing, frame, mat, protective covering, hanging rods) _____

Cost $ _____

Overhead _____ A $ _____

Salary (hourly rate x total hours) _____ B $ _____

Profit (10% of above two items) _____ C $ _____

Sub-total (A + B + C) _____ D $ _____

Commission (equal to D) _____ E $ _____

Retail price (unframed) (D + E) _____ F $ _____

Frame, mat, etc. _____ G $ _____

Retail price/framed (F + G) _____ H $ _____

*TO CALCULATE OVERHEAD

Take total business expenses for the year, such as dues, education, utilities, publications, postage, etc., but not including material costs. Divide this total by 12 to come up with a monthly overhead figure. For example, $3600 total expenses for the year, divided by 12, would equal $300 per month average overhead. Divide this monthly figure by average number of original pieces completed each month to arrive at overhead cost per original.

PRICING WORKSHEET FOR LIMITED EDITIONS

Title of work _____

Date printed _____ Quantity printed _____

Printer's name/address _____

Method of printing used _____

Price to print (per unit) _____ A $ _____

Artist royalty (10% of A) _____ B $ _____

Publishers profit (10% of A + B) _____ C $ _____

_____ Sub-total (A + B + C) _____ D $ _____

Commission (equal to D) _____ E $ _____

Retail price/unframed (D + E) _____ F $ _____

Signed piece additional cost _____ G $ _____

Retail price/unframed/signed (F + G) _____ H $ _____

Frame, mat, etc. (actual cost) _____ I $ _____

Retail price/framed (F + I) _____ J $ _____

Retail price/framed/signed (G + J) _____ $ _____

NOTES

CERTIFICATE OF TITLE

I, _____, certify that I am the creator of the artwork entitled _____

_____, medium of _____, size of _____, subject matter _____.

I created said artwork on _____ .

On this date, _____, I am transferring ownership to:

NAME _____

ADDRESS _____

SIGNATURE OF NEW OWNER _____

SIGNATURE OF ARTIST _____

DATE _____

CERTIFICATE OF AUTHENTICITY

This certificate guarantees that this print, number _____ of a limited edition of _____ prints, is personally signed and numbered by the artist.

ARTIST _____

ADDRESS _____

TITLE _____

MEDIUM _____

DIMENSIONS _____

YEAR PRINTED _____

DATE OF SALE _____

SIGNATURE OF ARTIST _____

DELIVERY MEMO

Delivered to _____ Date shipped _____

Address _____

Phone _____

Method of shipment and tracking # _____

DESCRIPTION OF WORK

Title _____

Date completed _____ Size _____

Medium _____ Framing _____

Miscellaneous _____

TERMS OF SALE

Purchase price _____ Sales tax _____

Shipping _____ Total _____

Cash/check _____ Credit card _____

Please acknowledge receipt of product by signing and returning one copy of this Delivery Memo

PURCHASER'S SIGNATURE _____ DATE _____

ADDRESS _____ PHONE _____

BILL OF SALE

Sold to _____

Address _____

Phone _____

DESCRIPTION OF WORK

Title _____

Date completed _____ Size _____

Medium _____ Framing _____

Miscellaneous _____

TERMS OF SALE

Purchase price _____ Sales tax _____

Shipping _____ Total _____

Cash/check _____ Credit card _____

→ Resale or transfer of work requires that artist be informed of the new owner and the price of sale. Should the price be more than $1000 over the original price stated herein, according to California state law, 10% of amount over original price shall be given to artist by seller.

→ Artist shall have right to photograph piece, if necessary, for publicity or reproduction purposes.

→ Artist shall have right to include artwork in retrospective show for a maximum of 3 months.

→ If artwork is rented out by purchaser, artist will receive 25% of rental income.

→ Artwork cannot be exhibited in public without written approval of artist.

ARTIST'S SIGNATURE _____ DATE _____

ADDRESS _____ PHONE _____

RECEIVED IN GOOD CONDITION:

PURCHASER'S SIGNATURE _____ DATE _____

ADDRESS _____ PHONE _____

REPRODUCTION RIGHTS RESERVED BY ARTIST

PROVENANCE

Artist's name_____

Title _____

Medium _____

Dimensions _____

Year completed_____

This artwork was completed by the artist noted above and was signed by the artist.

This artwork was acquired by _____ in _____.
 (Seller) (Year of purchase)

Ownership of the above described work was transferred to:

Name of buyer_____

Address of buyer_____

Phone number_____

on _____, 20_____ for the sum of $ _____ .
 (Sale date) (Purchase price)

BUYER'S SIGNATURE _____ DATE _____

SELLER'S SIGNATURE _____ DATE _____

Place image of
artwork here

PRICE LIST

	Title	Size	Medium	Cost/unframed	Cost/framed
ORIGINALS					
PRINTS					
OTHER					

ALPHABETICAL INDEX OF FORMS

BUSINESS BOOKS FOR ARTISTS

Art Marketing 101, A Handbook for Fine Artist

This comprehensive 21-chapter volume covers everything an artist needs to know to market his work successfully. Artists will learn how to avoid pitfalls, as well as identify personal roadblocks that have hindered their success in the art world.

Preparing a portfolio * Pricing work * Alternative venues for selling artwork
Taking care of legal matters * Developing a marketing plan
Publicity * Succeeding without a rep * Accounting * Secrets of successful artists

Licensing Art 101: Publishing and Licensing Artwork for Profit

Expose your artwork to potential clients in the art publishing and licensing industry. You will learn how to deal with this vast marketplace and how to increase your income by licensing your art. Contains names, addresses, telephone numbers and web sites of licensing professionals and agents.

Negotiating fees * How to approach various markets * Targeting your presentation
Trade shows * Licensing agents * Protecting your rights

Selling Art 101: The Art of Creative Selling

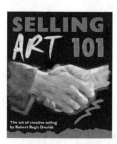

This book teaches artists, art representatives and gallery sales personnel powerful and effective selling methods. It provides easy-to-approach techniques that will save years of frustration. The information in this book, combined with the right attitude, will take sales to new heights.

Closing secrets * Getting referrals * Telephone techniques * Prospecting clients
14 power words * Studio selling * How to use emotions * Finding and keeping clients
Developing rapport with clients * Goal setting * Overcoming objections

Internet 101: With a Special Guide to Selling Art on eBay

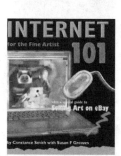

This user-friendly guide explains exhibiting, promoting and selling artwork online. It also teaches in detail how one artist made $30,000 selling her art on eBay.

Internet lingo * E-mail communication shortcuts * Doing business via e-mail * Meta tags
Creative research on the web * Acquiring a URL * Designing your art site
Basic promotional techniques for attracting clients to your site * Pay-per-click advertising
Search engines * Tracking visitors * Reference sources

A Gallery without Walls: Selling Art in Alternative Venues

This book will lead you to a greater understanding of how to select and then reserve the best space to exhibit your work. It will also teach you how to promote your artwork on a limited budget.

The Sacred Sales Spot * Themed events * The Red Dot Syndrome
Finding alternative venues * Art Teas * Making a penny scream * Pricing work
Promotion on a shoestring * Preparing a portfolio

ArtNetwork
PO Box 1360, Nevada City, CA 95959-1360
530·470·0862 800·383·0677 www.artmarketing.com

ART WORLD MAILING LISTS

Artists (46,000 names) .$100 per 1000

Architects (650 names) . $60

Art Councils (640 names) .$60

Art Museums (1000 names) . $85

Art Museum Store Buyers (550 names) $75

Art Organizations (1800 names) .$110

Art Publications (700 names) . $75

Art Publishers (1150 names) .$95

Art Supply Stores (800 names) . $65

Book Publishers (325 names) .$50

Calendar Publishers (100 names) .$50

College Art Departments (2500 names) $130

Corporate Art Consultants (175 names)$50

Corporations Collecting Art (475 names) $60

Corporations Collecting Photography (125 names) $50

Galleries (5500 nationwide names) .$400

Galleries Carrying Photography (320 names) $50

Galleries/New York (750) (more city/state selections online)$75

Greeting Card Publishers (640 names)$70

Greeting Card Reps (300 names) .$50

Interior Designers (600 names) . $55

Licensing Contacts (200 names) .$50

Public Libraries (1500 names) .$110

Reps, Consultants, Dealers, Brokers (1600 names) . $125

All lists can be rented for onetime use and may not be copied, duplicated or reproduced in any form. Lists have been seeded to detect unauthorized usage. Reorder of same lists within a 12-month period qualifies for 25% discount. Lists cannot be returned or exchanged.

Formats/Coding
All domestic names are provided in zip code sequence on three-up pressure-sensitive—peel-and-stick—labels (these are not e-mail lists).

Shipping
Please allow one week for processing your order once your payment has been received. Lists are then sent Priority Mail and take an additional 2-4 days. Orders received without shipping fee will be delayed. Shipping fee is $5 per order.

Guarantee
Each list is guaranteed 95% deliverable. We will refund 39¢ per piece for undeliverable mail in excess of 5% if returned to us within 90 days of order. We mail to each company/person on our list a minimum of once per year. Our business thrives on responses to our mailings, so we keep our lists as up-to-date and clean as we possibly can.

ArtNetwork
PO Box 1360, Nevada City, CA 95959-1360
530·470·0862 800·383·0677 www.artmarketing.com

LOCAL PROMO MAILING LISTS

Promote your open studio or exhibition by inviting local art professionals.
Our local promotion lists include the following eight categories:

Art publishers * **Galleries** * **Consultants, reps and dealers** * **Architects**
Interior designers * **Museum curators** * **Corporations collecting art** * **College gallery directors**

Some examples of counts follow. More geographic areas are listed online at www.artmarketing.com. Call or e-mail for a quote for your specific needs.

California	2700 names	$200
Northern California	1350 names	$115
Southern California	1350 names	$115
San Diego	200 names	$50
Los Angeles	525 names	$75
San Francisco Bay Area	725 names	$85
San Francisco	350 names	$55
New York City	1200 names	$115
New England	1000 names	$100
Boston	210 names	$50
Chicago	300 names	$50
Illinois	500 names	$65
Florida	600 names	$75
Georgia	245 names	$50
Hawaii	90 names	$40
Michigan	300 names	$55
Mid-Atlantic	650 names	$80
Minnesota	225 names	$50
New Jersey	350 names	$55
New Mexico	350 names	$55
Ohio	250 names	$50
Oregon	275 names	$50
Seattle	225 names	$50
Texas	600 names	$70

ONLINE GALLERY

NOT READY TO SPEND HUNDREDS OF DOLLARS TO HAVE A WEB SITE BUILT?

Take advantage of ArtNetwork's low-cost, high-exposure home pages. Our two-year plan is economical and allows you to have a professional "spot" on the web to call home.

Our 20 years' experience within the art world has made our site popular among thousands of art professionals. We contact these professionals annually via direct mail—they know us and the quality of artists we work with.

A home page with ArtNetwork will include five reproductions of your artwork, or you can get a double page of 10 pieces if you like. Each artwork clicks onto an enlarged rendition, approximately three times the size. Two hundred words of copy (whatever you want to say) are also allowed on your main page, as in the above layout.

Artmarketing.com receives between 400,000-500,000 hits per month—an average of 1500 users a day (and rising each quarter). The gallery is the second-most visited area on our site.

- We pay for clicks on Google for a variety of art genres: abstract, equine, nature, environmental, whimsical and many more.

- We publicize our site to art publishers, gallery owners, museum curators, consultants, architects, interior designers and more! Your home page on our site will be seen by important members of the art world.

TO SHOWCASE YOUR WORK ONLINE, GO TO WWW.ARTMARKETING.COM/ADS

ArtNetwork
PO Box 1360, Nevada City, CA 95959-1360
530·470·0862 800·383·0677 www.artmarketing.com

WWW.ARTMARKETING.COM

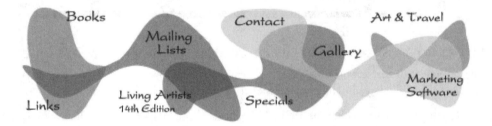

Books

Mailing
Lists

Contact

Art & Travel

Gallery

Marketing
Software

Links

Living Artists
14th Edition

Specials